HOWARD TAYLOR
PHENOMENA

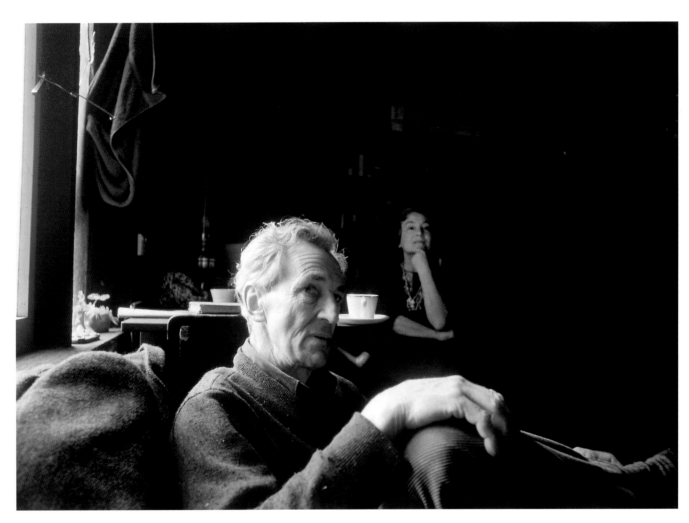

Howard and Sheila Taylor 1986

Gary Dufour

HOWARD TAYLOR
PHENOMENA

ART GALLERY OF WESTERN AUSTRALIA, PERTH
MUSEUM OF CONTEMPORARY ART, SYDNEY

This volume is published on the occasion of the exhibition HOWARD TAYLOR: PHENOMENA
A joint initiative of the Art Gallery of Western Australia, Perth, and the Museum of Contemporary Art, Sydney.

Tour of the Exhibition:
Museum of Contemporary Art, Sydney 17 September – 30 November 2003
The Art Gallery of Western Australia 5 February – 2 May 2004

This exhibition is supported by **Visions of Australia, a Commonwealth Government Program** supporting touring exhibitions
by providing funding assistance for the development and touring of cultural material across Australia.

Published by the Art Gallery of Western Australia
PO Box 8363, Perth Business Centre, Perth, Western Australia 6849
Telephone: +61 8 9492 6600
Facsimile: +61 8 9492 6655
Email: admin@artgallery.wa.gov.au
Website: www.artgallery.wa.gov.au

Curator: Gary Dufour, Deputy Director, Art Gallery of Western Australia, Perth
Essayist: Russell Storer, Curator, Museum of Contemporary Art, Sydney
Designer: Trevor Vincent
Editors: Gary Dufour and Allan Watson
Photographer: Greg Woodward
Printer: Lamb Print

An Art Gallery of Western Australia and Museum of Contemporary Art, Sydney, exhibition
presented with the support of the Government of Western Australia, the New South Wales Government,
'Key Organisation' grant funding from the Commonwealth Government through the Australia Council,
its arts funding and advisory body, and the Perth International Arts Festival. The MCA was established by the
University of Sydney through the JW Power Bequest, with assistance of the New South Wales Government.

Cover: Howard Taylor, *Light source reverse* 1994

National Library of Australia cataloguing-in-publication entry.

Dufour, Gary, 1954-,
Howard Taylor phenomena.

Bibliography.
ISBN 0-9750168 2 2.

1. Taylor, Howard, 1918– Exhibitions. 2. Art, Australian – Western Australia – Exhibitions.
3. Art, Modern – 20th century – Western Australia – Exhibitions. I. Art Gallery of Western Australia. II. Title.

709.94

ART GALLERY OF
WESTERN AUSTRALIA

❚ MUSEUM OF CONTEMPORARY ART ❚

Contents

Foreword

The *Art Gallery of Western Australia* and the *Museum of Contemporary Art* share a commitment to *Australia*, contemporary art and the challenge to bring the best art of our times to the widest possible public. This joint initiative to explore the achievements of Howard Taylor, one of *Australia's* most significant artists, through a retrospective exhibition and publication provides an opportunity once again to make an extraordinary body of work familiar at home and abroad.

One of *Australia's* most revered artists, Howard Taylor placed rigorous and intriguing demands upon specialists, interpreters, himself and the public over six decades. Based in the *Western Australian* forest town of Northcliffe, Taylor captured the changing light and colour of the *Australian* bush with unparalleled conceptual subtlety and artistic precision. His work demonstrates for us all that the more one looks the more enlightening experience becomes, and that the resources of art are constantly replenished by the very problems it seems to pose.

The tasks associated with successfully mounting a retrospective are always daunting, and we are thankful for the generosity and support shown to the *Art Gallery of Western Australia* and the *Museum of Contemporary Art* by the individual collectors and institutions that have made their works available for inclusion in this comprehensive overview of *Taylor's* career. The commitment of the lenders to the exhibition listed in this publication is exemplary. We are also deeply grateful for the unwavering support provided for this exhibition by our sponsors, and to *Visions of Australia* for a development grant.

On behalf of our boards of trustees, we would also like to express our appreciation for the extraordinary talents and efforts of the staff whose professional integrity ensured the achievements of the highest standards. In particular, we would like to acknowledge the curator of the exhibition, Gary Dufour, Deputy Director at the *Art Gallery of Western Australia*, and Russell Storer, Curator, *Museum of Contemporary Art*, who brought to this project insight, intelligence and a deep understanding of Taylor's work.

Over six decades this artist produced a unique group of paintings and sculptures that respond to ever-present natural phenomena. We are indebted to Howard Taylor, the patient observer who could make much of what was immediately to hand. His art enriches us all with the nuances and pleasures of colour, surface and substance, and rewards visual acuity, replenishes our perceptions and refreshes experience.

ALAN R DODGE Director, *Art Gallery of Western Australia*
ELIZABETH ANN MACGREGOR Director, *Museum of Contemporary Art*

Acknowledgments

An exhibition on this scale is the work of many individuals and reflects their combined professionalism, determination and generosity. First of all, I would like to thank Howard Taylor, Sheila and their family. Over the past twenty years they have welcomed me into the studio and their home. Their generosity of spirit and Howard's clear articulation of an artistic path pursued over six decades, have offered insights and rich rewards. I am grateful for the opportunity to study such outstanding art and for the friendship we have shared.

Many people have cleared a path and contributed to the success of this project. Foremost among them is Alan R Dodge, Director of the Art Gallery of Western Australia, who has strongly supported this exhibition from its inception and offered indispensable help along the way, with solutions to unexpected problems and support for key acquisitions. The path, however, is much longer, and I must acknowledge Anthony Bond of the Art Gallery of New South Wales, who in July 1983 took me to meet Howard Taylor for the first time and supported my work on his first retrospective in 1985. Between then and now at the Art Gallery of Western Australia many of my colleagues have contributed toward the realisation of this project. In particular, John Stringer and Margaret Moore recommended many works for purchase that have proved critically important to this exhibition.

Also at the Art Gallery of Western Australia, the contributions of Natalie Beattie, Ian Bell, Philip Burns, Sean Byford, Peter Casserly, Tanja Coleman, Jessica Commander, Robert Cook, Jenny Emmeluth, Adrian Griffiths, Vanessa Griffiths, Lynne Hargreaves, Lyn-Marie Hegarty, Paul Kelvin, Gabby Lawrence, Melanie Morgan, Natalie Scoullar, Maria Tagliaferri, Trevor Vincent, Kate Woollett and Greg Woodward have been in every way critical to the organisation of this retrospective and publication. The work of everyone who contributed to this exhibition has been exemplary and performed with customary but also extraordinary commitment and the utmost regard for the technical and aesthetic demands of all aspects of this exhibition. Together we shared the challenges and pleasures of actually transforming ideas into reality. All have my sincere thanks.

This exhibition would not have been possible without the enthusiasm and commitment of our partner, the Museum of Contemporary Art, Sydney. Elizabeth Ann Macgregor, its Director, responded to my suggestion immediately, and together we shaped an idea for a project that would bring the work of this outstanding artist to audiences, new and old, on both sides of Australia. Together with the counsel of Judith Blackall, Head, Artistic Programs and the insightful curatorial intervention of fellow Western Australian, Russell Storer, Curator our vision for 'Howard Taylor: Phenomena' was admirably realised, and our thanks go to MCA staff for the presentation of the exhibition in Sydney.

Assistance has come from many quarters, and in particular I am indebted to Douglas and Magda Sheerer who represent the artist, for their crucial contributions to this project. I would also like to thank Bill and Anne Gregory for their kind assistance. I owe a debt of gratitude to many individuals for generously giving of their time and assistance with the research, foremost among them being individuals and families of the many collectors who have contributed to the exhibition. I also want to acknowledge the work of Ted Snell, Daniel Thomas and Paul Green-Armytage, who have contributed to our understanding of Howard Taylor's achievements, and to colleagues in national, state and university galleries across Australia who aided my research.

On a personal note, I wish to acknowledge Siné MacPherson and our family, Hollis, Meredith and Hilaire. A shared sense of adventure first brought us to Australia, and their combined support has made my work on Howard Taylor, over the past twenty years, possible and our friendship with the Taylor family so rewarding. Thank you.

GARY DUFOUR *Deputy Director, Art Gallery of Western Australia*

Howard Taylor
maquettes for paintings
and sculptures
1956–2001

left to right:
Torso of a tree fork 1975
Study for *Heightened with light* 1980
Stick insect 1957
Study for *Segment of a sphere* 1987
Study for *Weathered jarrah* 1996
Plant figure 1977
Untitled [*Object in niche*] c1983
Study for *Heavy object* 1994
Untitled [*Landscape*] c1990
Figure in space 1978
Untitled [*Figure in space*] 2001
Study for *Heavy object* 1994
Study for *Masked landscape* 1982
Study for *Light figure* 1992
Study for *Sun wall* 1997
Untitled [*Contracurve*] 1994
Study for *No horizon* 1994
Study for *Light source reverse* 1994
Study for *Projection* 1995
Study for *Strange formations* 1995
Two phases 1978
Study for *Contracurve* 1993
Untitled [*White figure*] c1993
Study for *Four part unit* 1993
Study for *Four part unit* 1993
Study for *Internal cylinder* 1994
Study for *Wood on the ground* c1975
Classical figure II (Blackboy derivation) 1969
Study for *Column* 1997
Study for *Forest post* 1996
Column 1969
Untitled [*Object in space*] 1956
Study for *Discovery* c1990
Study for *Discovery* c1990
Hollow 1990
Landscape 1978

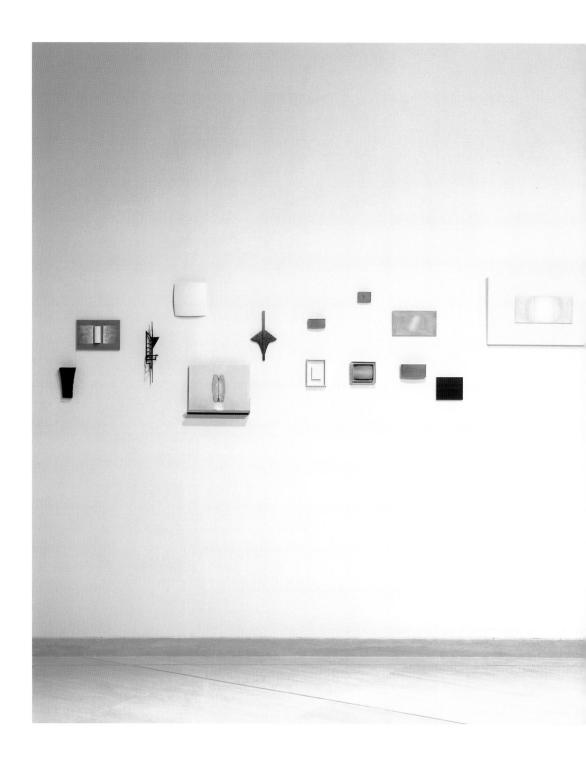

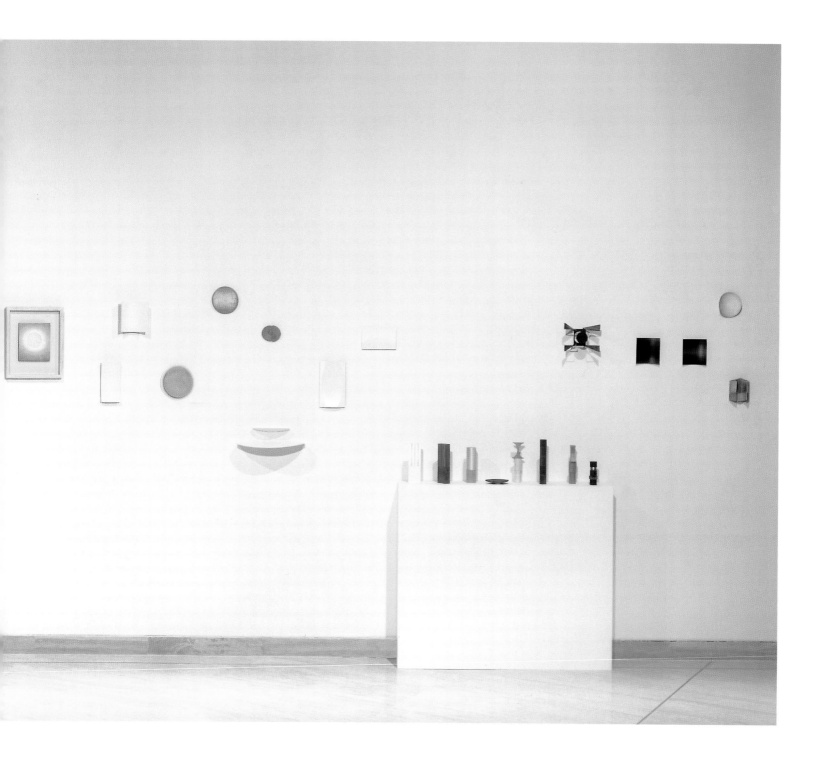

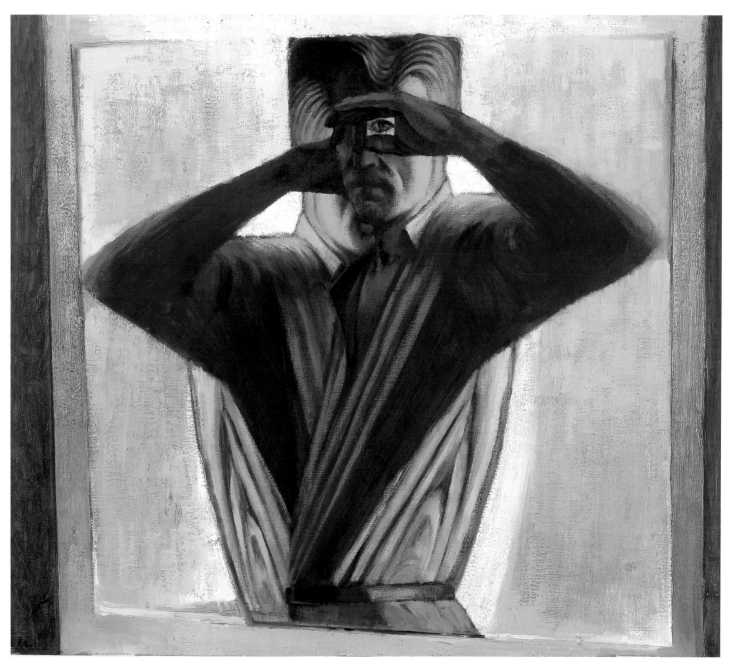

Double self-portrait 1959

The Inventive Eye

The interest in the Object/Space/Light/Paint materials is complex and has its origins in learning to paint and observe natural phenomena.

There was a concrete link to painters of the past.

Painting as a structure — an object made.

Structure or even sculpture itself appeared.

Sculpture steps out of painting.

Light problems, found in shaped work, particularly rely on optical contributions.

So sculpture steps back into painting where the conditions can be fixed.

This gave interesting moments — the realisation of the two different disciplines.

Another alternative was to take colour (paint or coloured materials) to sculpture.

The majority of my work was making equivalents for an observed visual experience.

The overall concern was for landscape or related elements of nature.

Suns and moons as subjects were increasingly rewarding as structural problems — what one could do with the movement, light, atmosphere within the flat surface of a panel or canvas.

Avoidance of associational or symbolic attachments was absolutely necessary.

Recollections of movement with discs and spheres and circles.

> Primitive circle of Tasmanian Aboriginals — Hobart.

> Hubs of cars in the 60s while taking cups of tea in café.

> The observation so clearly felt in illustrated miniatures, Masters of 16C.

> The first look at Mona Lisa. An Object in Space — not the smile etc.

HOWARD TAYLOR 1997[1]

In late June 2001 I found myself again at the studio with Howard Taylor. As always the scene was orderly and there was a crisp sense of anticipation in his voice as he began to describe several projects set to go. Another lengthy period of observation and planning was drawing to a close. The essential decisions had already been made and a new group of major works would soon emerge. The construction drawings for panels had been dispatched; the underpainting, in a monochrome deep Venetian red, was

Study for *Veranda*
Studio interior, Northcliffe 2001

Untitled [*Broken light shadows***]**
c1995 (detail)
pencil on newsprint
22 × 21.3 cm
Estate of Howard H Taylor

finished on two of the panels. I got a sense of how his ideas were migrating from nurtured concepts to physical shapes and intricate surfaces.

That day Howard Taylor's attention was devoted particularly to a new full-size maquette – a white wall sculpture that was an adaptation of some of his previous depictions of tree trunks and colonnades. This time the object of his observations was a veranda, and how the posts in the relatively shallow space of a domestic porch operate visually when they are activated by tone, texture and shadow. His description of it as a 'little veranda job' understated a number of things: the intensity of his concentration on finding a solution to a complex pictorial problem; the significance to him of the colonnade; the fact that he was restating and renewing a motif with origins stretching back five decades. In this case it was the particular visual problem of shadows and structures: he was seeking to find an ever more refined solution to a comment written in 1956 on a study for *Wood structure* 1956: 'Incorporate shadows into structure of box. Not naturalism in light – suggest Nolan structure.'[2]

Veranda, although never completed, restates a theme that runs through *Farm landscape* 1996 to as far back as Untitled [*Trees to sky*] 1963 and beyond. *Wood structure* is his first extended investigation of the integration of shadows within the structure of the form. Each time he returned to this theme he revelled in the visual complexity of random and orderly broken light shadows.

That day in June, Howard Taylor's studio was much like I had found it on any of my visits over the previous two decades. A few new 'jobs' on the go, notes for what had to be done, including detailed notes for what needed to be built in the adjoining woodworking shop, and a dozen or so small oils tacked along two walls of the studio. Each painting was the product of his on-site observations of everyday things, all executed *a la prima*. From memory there were small paintings of a vase of red geraniums, some lisianthus, a forest interior in green and drawings of Salmon Beach, tree trunks, farm landscapes, tree canopies and colonnades.

Reflecting on that day – that one room, my last discussion with him – the methodology that guided his work over six decades becomes clearer. Howard Taylor was a

patient observer of his circumstances and a detailed planner. The first of these traits was evident in his earliest POW camp drawings and the second became apparent not long after, when he took up the rigorous and unforgiving medium of egg tempera.[3] He paid attention to the details and made much of what was close at hand.

Rather than concerning himself with the metaphysical 'essence' of painting, Taylor was interested in its construction, in invention – searching through the ideas and paradigms that have shaped it over the centuries. He always felt obliged to understand what artists before him had achieved, and readily acknowledged these influences on his pursuits:

Salmon beach and *Day time moon*
Studio interior, Northcliffe 1996

> *'Visual appearance' is an expression of contempt now and the simple kind of seeing – of recognition – of putting a label on – has become all too familiar. Working figuratively with landscape is rather out too, but it is beyond me why we have turned our backs on so many centuries of serious endeavours in seeing. I have found the knowledge accumulated over the past most valuable, and far from being restrictive it is most definitely an 'incentive' (constructive). My work is largely non-naturalistic, protracted and designed, in fact sometimes so reliant on procedures of a planned nature that for relief and pleasure I get outside for spontaneous drawing and painting. The contrasting methods balance up and enlighten each other.[4]*

If we look to the beginning of the twentieth century, two almost antithetical approaches to art can be seen emerging, one metaphysical, the other more historical and analytic. The list of artists from cubism onwards who took up the metaphysical path is long, and the twentieth century saw outstanding contributions from Pablo Picasso, Wassily Kandinsky, Kasimir Malevich, Paul Nash, Graham Sutherland, Sidney Nolan, Fred Williams and, with her landscape-inspired work, Agnes Martin. The other list is somewhat shorter; it includes names like Marcel Duchamp, Francis Picabia, Bridget Riley, Robert Ryman and Gerhard Richter. Each in their work seeks a pragmatic approach to renew painting. This metaphysical/historical division was summarised in 1944 by Barnett Newman: 'If we could describe the art of the first half of the twentieth

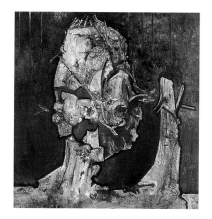

Fred Williams 1927–1982 Australia
Stump II 1976
oil on canvas, 122 × 122 cm
Art Gallery of Western Australia
Purchased with funds from the
Sir Claude Hotchin Art Foundation 2001

Bridget Riley born 1931 England
Remember 1964
emulsion on hardboard
106.7 x 111.1 cm
Kerry Stokes Collection, Perth
© Bridget Riley

century in a phrase, it would read as "the search for something to paint"; just as were we to do the same for modern art as a whole, it must read as "the critical preoccupation of artists with solving the technical problems of the painting medium".[5] Essentially a critique of Impressionism, Newman's essay emphasised how the look of painting was forever changed at the end of the nineteenth century, when the Impressionists proposed their solutions to the problems of colour.

Throughout the twentieth century, while both groups of artists shared an approach to painting that veered away from representation, the thinking of those committed to history and analysis diverged significantly. Duchamp saw 'the paint tube as a springboard for reaching much further … Pure painting as an aim in itself is of no import. My aim is something completely different: for me, it consists in a combination, or at least in an expression, which only the grey cells can reproduce.' Duchamp saw in art a means to sharpen the senses for the relativity of all thoughts and to bring a new awareness that 'essences', too, are contingent constructions of the mind – nothing is absolute in art, nor in any other field of thought.[6]

Taylor can clearly be identified with this second group – those who created a path forward by analysing the achievements of the art of the past. His pragmatic approach to 'new' ways of painting emphasised seeing as being of paramount importance – recording the visual specificity of each phenomenon observed, pictorial problem-solving, the rediscovery of colour and a desire to make his means visible, his techniques conspicuous. This historicist predilection occasionally caused audiences to perceive his works as oddly anachronistic, stylistically out of sync with what was thought to be contemporary. However, what prevails throughout is his strong belief in the contemporaneity of the visual problems addressed by painters in the past and in how this understanding liberated his style and gave him greater choice of artistic modes of expression.

The early painters gave us invaluable knowledge in their concern with natural conditions. This knowledge is valid today because we can still use our eyes and rely on

the fundamental design laws they formed, and paint the most abstract work if we wish. Visual perception involves light behaviour, paint and materials.[7]

Paintings are not locked in the past, and neither are the pictorial problems they addressed. What 'has passed' are only the circumstances that allowed them to be painted, those specific ideologies of an age that saw in nature the romantic, the sublime or the divine. 'In my case the pictorial side is architectonic and not expressionistic or emotionally inspired. Mine develops from nature and visual perception and hangs on to that to the last.'[8]

Taylor's lifelong interest in gaining an understanding of historical artistic achievements is equally evident in his notebook annotations and his recollections of the rare encounters he had with great works of the Western tradition. Apart from one-day student trips from Birmingham to the National Gallery in London in the 1940s, his only other opportunities to see such works were during visits to Europe in 1960 and 1980. The most recent indication of his continuing interest in the past is a list sent to a bookseller in the 1990s:

These are a few specific books I would like that might start the game off.
Also an indication of what book lists might interest me.
Nicolas Poussin — his landscape painting (not figure)
 or landscape in figure painting.
Paul Cezanne — drawings and watercolours.
Seurat — drawing & studies.
Rembrandt — drawings, particularly pen & wash
 (not etchings) of landscapes.
Samuel Palmer — drawings — not just Shoreham
 period but right through.
Piet Mondrian — drawings — early figurative studies, etc.[9]

Howard Taylor's interests lay in what he felt were the fundamental aspects of vision that had been confronting artists and stimulating innovative solutions since the Venetian colourists.[10] He considered vision to be the artist's central concern throughout history and, in an essay published in 2001, quoted Nicolas Poussin's comments on this subject:

> There are two types of vision: the 'aspect' — the simple and natural kind, which could be qualified by reflective vision; and the 'prospect' — attentive observation of objects which looks for the means of understanding vision and perceiving objects.[11]

What distinguishes Howard Taylor's work is how he pursued this interest through the close observation of the landscape in which he found himself and the emphasis he placed on the interaction of support, colour, surface texture and technique in 'getting to grips with the painter's vision'.[12] He described his involvement with bush life and its structural elements as a close analytical one — that of a participant rather than an onlooker. His primary interest was in 'the simple use of materials, with direct working processes and basic elementary form to recapture experiences gained from a long-lasting absorption in forests and trees'.[13] His letters on and discussion of this topic provide enormous insight into the complexity of the interaction of what he described as the elements needed in an artist's 'kit bag' if one was going to achieve a result that would be a worthwhile extension of the painter's vision.[14] At various times, and in particular series or groups of works, he often isolated an individual element from the 'kit bag' for in-depth consideration and study. The ground rules for many of his compositions were set by his notional nomination of a particular element as the dominant and the others as subordinate when conceptualising the visual problems of a subject. This component is then treated in individuating detail to support his equally strong desire to offer spectators access through a transparency of technique. The simplicity of his means, hiding nothing from view, also provides each work with an unsettling immediacy.

Taylor's works are active in our presence and activated by our presence. His results

do not come from rapid improvisations undertaken spontaneously, but are the results of a previsualised design process undertaken with unerring workmanship. 'The overall interest in landscape and natural phenomena goes beyond the particular object/space problems but the simple solid – particularly the sphere or disc – continues to fascinate – the movement series of suns and moons. Associations and content. The painting is the content.'[15]

In his search for something to paint, Taylor often revisited subjects and motifs he had explored decades earlier. Three motifs in particular can be seen to dominate: object on the ground, object on the wall, object in space. As a group they take on a pivotal significance in his 1990 exhibition 'Howard Taylor: Paintings – Pastels'. These three configurations of objects are all essentially preconditions for the perception of any object in any context, as they establish a structure for spatial contrast. Object on the ground, object on the wall and object in space were each extensively explored. Each is an abstract configuration used to establish contrast, an essential aspect of the creation of volumetric space in painting since the Venetians. For Taylor they mark a return to basics and a shift from the figure/ground concerns of the previous decade to suns, moons and wall sculptures. They also highlight the importance he placed on context as a guide to perception from his earliest works such as *Portrait of a blackboy* 1950, which is an object in space. His opinion on the subject was, by the 1990s, unambiguous:

> *An isolated colour or other element is a specimen only – an I.D. card.*
> *Remove a sculpture form the environment it is designed for – murder.*
> *Give a detail of a painting – murder.*
> *Cut out a head from its background – murder.*
> *Take a lemon say from a still life group – a specimen only.*
> *A colour area from its surround – a specimen.*[16]

As a group the three motifs – object on the ground, object on the wall and object in space – first appeared in a small drawing Untitled [*Spheres in space*] c1956–1958.

Study for [*Light figure*] 1989
Sketchbook 88–89
ink on paper, 14 x 9.5 cm
Estate of Howard H Taylor

Untitled [*Spheres in space*] c1956–1958

Study for [*Structure–chiaroscuro*] 1955
pencil on paper, 9.8 × 15.6 cm
Study for *Flying machine – fins* 1958
pencil on paper, 9 × 14.5 cm
Estate of Howard H Taylor

The column 1950

In this pencil drawing, two spheres, one translucent and one opaque, occupy a shallow interior perspective space. The use of a single light source creates the remainder of the dynamic, the opaque sphere casting its shadow on the wall and the translucent sphere concentrating the same light to create a 'light figure' in space.

These three configurations of objects appeared together in a critical juncture in 1989, but they can be independently traced back to paintings and sculptures in each of the preceding decades. In the 1950s the themes of object on the ground, object on the wall and object in space were used by Taylor to set up the spatial dynamics of what can only be described as his conjectural representations of the landscape and his schematics for objects and their contexts. *The Flying machines*, for example, are all presented hovering, grounded or in space. *Stick insect* 1958, the wall reliefs of 1963, *Weathered jarrah* 1997 and paintings such as *Forest land* 1982 and *Light source reverse* 1994 were all conceived as objects on a wall.[17] *Creature* 1955 also contains an object on the ground – a small sphere in the upper left corner. Untitled [*Object in space*], a painted metal sculpture from 1956, and the painting rendering it as a still-life subject viewed from directly above – Untitled [*Object in space*] 1958 – extend these same motifs.

Taylor's description of his work from the 1970s reflects on the program that had guided it from the 1950s:

> Earlier paintings had been concerned with the observable surrounding bush in the hills at Piesse Brook. A most striking feature at the time for me was the burnt black remnants of trees and tree stumps, with the vivid green re-growth in contrast. So colour came into [The black stump 1975] from earlier associations – tree columns, black charcoal burns, varied new greens. The formal grouping is inherent in most of my work and the spiral growth movement is seen against this and consequently amplified. The group can be seen as an example of the intention to make equivalents for an experience of landscape. Simplification, reduction down to the fundamentals of a complex naturalistic subject.[18]

Taylor's pursuit of the fundamentals he describes here drew critical attention to his

The black stump AMP Building, St Georges Square, Perth 1975

work early. In addition to being an insightful critique of work produced for his 1960 exhibition, the comments of CG Hamilton could be seen to map out a program of work that, as we know now, was to occupy his attention for years to come:

> Strong individual approach and style — Based on observation and meditation and selection. Not abstract but synthetic. Puts down objects against the ground or in space. Often paints ideas, emotional backgrounds. Bush — objects — machines. Concerned with aspects of bush — forms compose space-patterns (objects, space between, depths, distances) … Intellectual approach to abstraction. Colours suggested by earth, sky, atmosphere, light, colour patterns incidental. They reinforce surface.
> Contrasts and progressions: Convex—concave, light—dark, warm—cool, pale—rich, strong—weak. Contrast between living and dead strongly-felt. Growth and decay?
> Single forms — rocks, stumps, trunks.[19]

In the 1980s Taylor began consolidating four decades of his observations in the bush and refining ideas about objects in space, whether forest figures, tree trunks or atmospheric light. It was also during this period that he turned to the sun and the moon as most suitable subjects for study.

> As a landscape painter concerned with observation it occurred to me, in the course of a series of paintings of suns and moons, that the latter is subject to so many changes of light and therefore visual form that this may conjure up romantic associations. The sun remains constant (given, in both cases that the atmospheric conditions don't produce untypical behavior); it is the source of light and life, and pictorially can give a longer period of contemplation which tallies with 'architectonic' aims. If divested of associational values, the sun and moon become excellent objects in space studies.[20]

In 1976 Taylor was once again drawn to phenomena of landscape that appear to lack any material properties but fall more into the category of visual effects — responses to illumination and the circumstances of weather patterns. These paintings of rainbows, wind and clouds each capture a brief temporal moment, an encounter

with a unique visual experience. This body of work appears, however, to have eluded consideration in discussions of the artist – perhaps an aversion to the romantic associations of these landscape subjects and Taylor's opinion that the purpose of art is not to offer revelations of the transcendental. To him this was, again, ideology, not art. As with his other works, these landscapes were not put forward as metaphors for a transcendent experience in nature. For him they are physical objects in the space of nature – visual facts that transcend ideology. While his 1976 landscapes do fulfil the criteria of atmospheric encounters with nature – the open skies, colourful rainbows, illuminated foliage and clouds – they raise these same atmospherics to another level. They establish the themes that prefigure two decades of forest and light figures. It is the ambiguous visual characteristics of natural phenomena that foster this interest and his production.

In the more recent, larger scale abstractions these characteristics allow him to transpose a particular visual phenomenon, as distinct from its form, and introduce it as a motif and the painterly structure for light effects. The figure/ground works of the 1980s, the rectangles within rectangles, allowed him the same opportunity to hone this shape-shifting methodology and combine disparate observations of visual experience in paintings and sculptures. Despite formal reconfiguration, the core of his art remained focused on learning to see – the painter's vision. He took what at first seemed ephemeral and, by making it the object of empirical study, turned this idea of observation back on the viewer by re-presenting visual sensations from the world as the subject for sustained attention through his art.

Even with the weather landscapes, Taylor was recording and transporting the perceptions of what he saw to create finished works. While they may have the look of paintings done on the spot in the open air, as one might have expected, they are studio paintings produced from notes taken in exacting detail and recorded in one of his ever-present sketchbooks. These notes on landscape phenomena served as a resource of observations to be reviewed and reassembled for other purposes in future years; in particular they often appeared as subjects in the figure/ground, objects-in-space and

Landscape with tree columns 1996
oil on canvas ground on
composition board, 23.5 × 32.5 cm
Art Gallery of Western Australia
Purchased with funds from the
Sir Claude Hotchin Art Foundation
1996

suns-and-moons works throughout the 1980s and 1990s.

Accumulating information in this way allowed him to refine his interest in vision – to understand how we see and to define how the interaction of support, colour, surface texture, brush stokes and technique can be used to unbind landscape from the traditional frameworks of history and romanticism. 'I decided some time back that signification and/or symbolism was not for me and better relegated to the unconscious … It's going to come out anyway.'[21] Like other modernists throughout the twentieth century, Taylor strove to fracture the unity of representation and slow down the immediacy of recognition. By rupturing contiguity in a world of appearances, he sought in his works to create a pause or brief rift in the timing of recognition, so a subject, no matter how traditional, can be seen anew – as a new visual phenomenon to be experienced in the present. Appearance is rendered on a surface not in correspondence to an individual incident, although the majority of works were in fact stimulated by quite particular observations. The actuality of each work exists in the present, not as a transcription of a past moment. Taylor creates a shared moment to experience the visual phenomena of each painting in the present. By returning to a subject time and again he tips his hand and lets us in on the visual problems to be solved.

> This would involve all considerations of making — materials, paint/colour, design structure. It is a process of pictorial discovery and could lead to naturalism or to nonfiguration. And has, in the end, to fulfill and amplify the subject, to gain a rightness in itself. That is my understanding of idea or expression … For me early drawings are made from a subject observed visually, and not imagined and then described.[22]

We are, seemingly, given access to an image that may otherwise remain out of reach – otherwise unknowable or at best only to be experienced as a glimpse of something ephemeral. In Taylor's paintings and sculptures the unknowable is made a little more real, and the scale of each work serves to place us within what we see. The surface activity and the shaped and worked panels reach out to the viewer. What we

might have called the simpler things in the landscape – rain, sunshine, clouds, a pasture, a stand of trees – are revealed as immensely complicated when attended to in detail.

Howard Taylor set himself complex problems, and in their resolution sought to take viewers with him beyond what he described as simple recognition. Gerhard Richter described his endeavours to create analogies for what exists – what can be seen if one takes the time to look – when describing his own landscapes in 1970:

> I would like to try to understand what is. We know very little, and I am trying to do it by creating analogies. Almost every work of art is an analogy. When I make a representation of something, this to me is an analogy to what exists; I make an effort to get a grip on the thing by depicting it.[23]

With this as a goal, an endless search for what to paint slips away into insignificance and the experiment that is painting can dominate. For Taylor, creating material analogies for often immaterial visual effects opened a breadth of possibilities for how to paint. Some solutions were based on pragmatism, such as his adoption of custom-built panels (marine plywood over western red cedar) as a preferred support. This material is a durable surface that allowed him to move fluidly from maquette to full scale and build up an impasto layer (*Heightened with white* 1980), easily create a shaped surface or one with multiple layers (*Light source reverse* 1994) or sand the surface back completely to start again and create incisions below the surface of the picture plane (*Sun wall* 1997, *Discovery* 2000). Other practical solutions also involved re-using an object to tackle a new pictorial problem, such as when the wall sculpture *Forest column drum* 1994 was cut in half after his 1995 exhibition to become first the subject for *Studio wall* 1999 and then the support for *Projection* 1999. Still other solutions evolved out of years of experience and were often adopted as guiding principles. One of these was his strong belief in the need to contrast pictorial elements in order to define form.

Gerhard Richter born 1932 Germany
Seestucke (Seascape) 1998
oil on canvas, 290 × 290 cm
San Francisco Museum of Modern Art
Fractional gift of an anonymous donor
© Gerhard Richter

Study for *Light figure* 1992

The 'contrast' could be hue or intensity or value or line or definition or texture or contour. They can help or counter each other. My increasing belief (being of Western cultural background) is that light is the most powerful of these. From the early use of line and sculptural modelling, light is used increasingly 'to define' form and chiaroscuro/atmospheric concerns, and various forms of Impressionism reach symbolism/expressionism until realism, and the object is rejected and the painting itself is the expression of experience, becomes the object.[24]

During the last two decades of his life Taylor explored this concern for optical contrast through increasingly minute adjustments of transparency, opacity, texture, underpainting, gloss, hue, shape or colour, using the artist's 'kit bag' to transform nature observed into works of outstanding formal clarity and intellectual resolve.

Light figure 1992, a large sun triptych, was a practical solution that allowed him to work on at an increased scale. This new scale engaged the viewer as an active participant in the optical dynamics of his works. In one sense each viewer determines what they see, as optically both the hue and the contrast in the painting appear to shift as one moves from a side to a front viewpoint. This chromatic effect can be partially explained by the fact that yellow, unlike other hues, retains its intensity in both bright and lower light levels whereas bright light has a bleaching effect on the perceived value intensity of other hues. 'Same value. Reads twice as dark ... From dark into light around the figure. Figure has same value.'[25] Also, unlike *Sun figure* 1989, where the central disc is a built-up burnished area that sits above a semi-gloss ground, the figure and the ground in *Light figure* share the same surface plane. Horizontal brushstrokes dominate and overlap the edge of the sun in *Light figure*, and this perceptually pulls the central figure into the background. *Light source reverse* 1994 utilises another alternative in the central disc. In this case gray, in vertical brushstrokes, is 'stretched' across a surface of brown executed exclusively in horizontal brushstrokes. Taylor's choice of brown is of interest as it has been described as a 'contrast colour', a colour that does not effectively identify a spatial volume when seen in isolation. Its representational

effectiveness is achieved only in relation to other more saturated or brighter colours such as gray and, most obviously in *Light source reverse*, to the violet and blue outer rings.[26]

The scientific explanation of colour vision is a contentious field, the leading theory in one decade often being thrown into doubt in the next; but if there is one point researchers into vision in the last fifty years have emphasised it is that colour is *relational*, not just in terms of adjacent contrasts, but in terms of the total effect of luminosity reflected from a visual field.[27] Residence for thirty-five years in a single area – Northcliffe, Western Australia – assisted Taylor in his exploration of colour relations. In that same location, day after day, he could observe the colours of the natural world around him, in features both near to hand and far away, to evaluate the changes in chromatic hue, density and transparency. This familiarity with location allowed the emergence in his work of a unique perspective on the relational qualities of colour and the effects of light, texture and distance.

Some of Taylor's mergers of visual experience with pictorial structure bridge the gap between sculpture and painting. This is particularly apparent in the resolution of the optical contrast in works that bring his tree trunk or colonnade series to a conclusion. In 1995 the perceptual problem of a forest colonnade was first addressed in the site-determined installation that formed the centrepiece of the exhibition 'Howard Taylor: Constructions–Paintings–Drawings–Maquettes'. A wall sculpture, *Colonnade* 1995, combined paintings executed directly on the wall *in situ* with seven painted steel cylinders. On reflection he was unconvinced by this solution, feeling that the vagaries of the light situation compromised the degree of resolution he required. His next approach, while unusual, was quite simple. He constructed a maquette, *Columns* 1995, and used it, in a situation where he could control the light, as the still-life subject for the painting *Colonnade study* 1995. He paired this work with another extension of the tree-trunks motif, *Farm landscape* 1996, and with these two works brought to a successful conclusion a series that spanned four decades. For him the answer was for sculpture to step back into painting, where he could control the

Internal cylinder, No horizon and Colonnade
Galerie Düsseldorf, Perth 1995

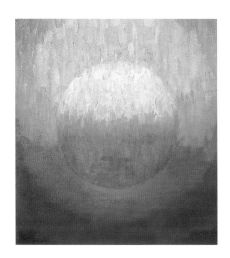

Two eras 1985
oil on paper ground on
composition board
53.3 × 48.8 × 4.2 cm
Art Gallery of Western Australia

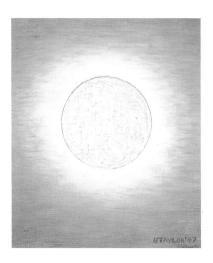

Study for *Sun wall* 1997

colour relations. 'Painting – fixed situation. Sculpture – should be also a fixed situation. A solution – a painting of sculpture giving a fixed situation.'[28]

Taylor's own thoughts on particular pictorial problems provide insight into how he pared back the variables and isolated his means both to clarify the actual visual problem to be solved and to calibrate the success of the solution to be pursued:

Light of the natural kind has concerned me for a long time in modelling objects in their environment – landscape subjects, still life and also sculptural subjects as paintings, both figurative and non-figurative structures. The perception of light in the natural conditions of landscape developed increasing concern for the dimensions and quality of paint behaviour, and this led logically to examination of techniques — particularly those masters of the past concerned with realistic form revealed by light. With Impressionism/Divisionism light was seen as colour, but this led to the dissolving of form [in] solids. The painting Sphere has the light demonstrating a strong direction and is of a tangible nature. The movement commences with the colour of the Impressionist theory period and converts itself into that of the lightness/darkness concept. So it could be said to embrace two eras of thought of light in using it to define form. Extreme Impressionist work was found to dissolve form rather than define it, so there is a reverse order in that the 'light/dark' light re-finds the form of the sphere.

In continuing engagement with landscape and of observable visual phenomena there has been repeated involvement with objects or solids in space. The Sun wall attempts to capture the experience of glancing at the sun and finding the focal point obscured by an impenetrable disc or plate. It is dark, mirror-like and in a flash repels. The radiance surrounds the centre. Preliminary studies led to a 'non-colour' for the disc, but flat burnished and leading out through violet (non-light side of the spectrum) to the red and yellow of brightness. The overall scheme is managed through play of values, transparency, opacity, contours or edges. The sculptural or structural low relief provides the necessary contour to emphasis the flatness of the disc and its separateness

from the atmospheric surrounds. The disturbing shock to perception is followed by a continual play of visual relationships and the difficulty of the eye to focus or rest.[29]

Concurrently with his work on *Sun wall*, Taylor was addressing an almost totally opposite pictorial problem in *Day time moon* 1997. As with *Sun wall*, the subject was something he glimpsed only briefly, in this case a full moon observed during the day while driving to Northcliffe. A slightly overcast sky obscured the moon beyond. It was obvious this would require a different treatment: unlike the disc in *Sun wall*, the focal point of the painting was elusive – the immaterial reflected light of the sun. In *Day time moon* there would come into play a technique he first adopted when working in egg tempera fifty years earlier. At that time he had reached back into the history of painting and taken up an interest in underpainting, a practice largely abandoned with the advent of Impressionist techniques. In a description of *Bush structure – flight* 1956, Howard Taylor describes his adoption of underpainting as a preferred technique for his oil paintings: 'Would need a *planned* painting perfectly and would possibly allow for adoption of tempera technique of underpainting dark to obtain opaque, translucent, transparent. This may be the answer to sinking in and drying variously matt and glossy.'[30] Underpainted colours became pivotally important throughout his career, as he regularly relied on what this richly stratified subsurface of colour could contribute to the chromatic effect. By the 1980s he had refined a technique that involved using a dark underpaint for his lightest paintings such as *Light figure* 1992 and light underpainting for the darker works like *Forest land* 1982.

Underpainting offered the perfect solution to his pictorial problem, as it produces an effect called halation when used with translucent glazes, and a similar effect – the apparent spreading of light or colour beyond the identifiable boundaries of an individual brushstroke – when the medium is opaque. In *Day time moon* it is the combination of the opacity of the broad final brushstrokes being influenced by the coloured underpaint that creates an analogy for the perception of reflected light against a pale sky. It draws you in and captivates you with the sheer visual pleasure of

Study for *Light figure* 1992 (detail)
ink and pencil on paper
33.2 × 24 cm
Estate of Howard H Taylor

29

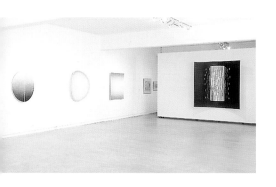

Divided sphere, Hollow,
Counter space and *Discovery*
Galerie Düsseldorf, Perth, 2000

colour and surface. Perhaps of even more importance in realising this is the contrast between the texture and the individual characteristics of each brushstroke. *Sun wall* and *Day time moon* were both particularly complex and satisfying projects, which occupied him for the better part of a year. 'Work here has been leisurely in painting and sculpture. Have done a moon and a sun painting (last year). The sun being a particularly awkward so and so – trying to get that flat centre that blasts you when you glimpse it. The two subjects moon, sun could be the last of the line.'[31]

His paintings offer little surprises, introducing you anew to or re-acquainting you with the recollection of a colour specific to a particular locale or an object illuminated in the forest or against the sky, glimpsed only for an instant. To achieve this he used visual analogies rather than the exacting mimetics of illusion to trigger visual memories. Equally, he never totally separated spectators from confronting the intimate and immediate evidence of how a picture is made. His focus, and by extension ours as well, never strayed far from those elements that play a part in the material production and reception of paintings as objects in space. Each object is a material summing-up of what he considered the essential components of painting: materials, paint/colour and design structure.

In the 1990s one sees in the clarity of his means a renewed vitality as he came to grips with 'the painter's vision'. His work embraced an ambitious new scale. Light, land and pictorial structure came under increasingly close scrutiny. Suns and moons dominated as subjects during the first half of the decade, with wall sculptures, forest figures and colonnades gaining more prominence later. It was a time of review. Small maquettes from decades earlier were reworked into new sculptures like *Forest post* 1998, or became still-life subjects in *Tree fork fragment* 1997 and *Charred forest fragment* 1997. Column forms defined with light, which had been resolved as structures much earlier in paintings such as *Heightened with white* 1980, are revisited and emerge completely redefined in *Discovery* 2000. Again a single column in light is the subject, but this time the knowledge gained from *No Horizon* 1994 has influenced the form, and the technical discoveries of *Sun Wall* 1997 and *Open country II* 1982 – or, even further

back, the incised surfaces of his 'bush forms' of 1963 – are combined to create the necessary optical contrast so a central column can again hover in a newly defined space.

Works such as *Discovery* 2000, *Light source reverse* 1994, *Bush fire sun* 1996 and so much of the work from earlier decades reveal the achievements of a mature artist, confident in his ability, masterful in execution and confronting a seemingly endless wellspring of conceptual problems. His work offers a pictorial or sculptural solution with the confidence of a lifetime of carefully considered propositions. Taylor's whole career is a succession of outstanding achievements, and in his last two decades a new clarity in his approach and a deep understanding of the landscape enriched the experience of art for all of us, if we offer it only patience and attentive observation. He offers in return a path for the renewal of art, a path filled with the nuances and pleasures of colour, surface and substance that rewards visual acuity, replenishes our perception of the world and refreshes our experience of place.

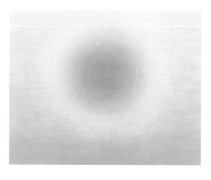

Bush fire sun 1996
oil on canvas, 122 x 152 cm
Wesfarmers Collection

> *Long absorption in timber forests, the visual sensations of light, movement, colour*
> *and structural elements involved the columns, cylinders, verticals. In looking at forest*
> *closely and from within [I] attempt to regain and recapture these experiences. [My]*
> *works show the influence of that association and [it] is the overriding factor. The*
> *work process now has increasing interest in bringing materials and basic simple forms*
> *to become equivalents for moments experienced and recalled from associations with the*
> *bush... These works are the essence of and equivalents for experiences remembered.*[32]

Howard Taylor's work is simultaneously pragmatic and poetic.[33] Over sixty years the clarity of his vision, paired with a purposeful determination, produced works of enormous complexity, delicacy and intelligence. The magnitude of his talent – not single works, but many great works across an array of mediums in two and three dimensions – reveals an artist who never stopped looking and never stopped experimenting with new ways to share the daily visual discoveries of someone attentive to the everyday experience of being in the world.

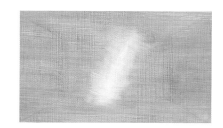

Untitled [*Figure in space*] 2001

GARY DUFOUR

31

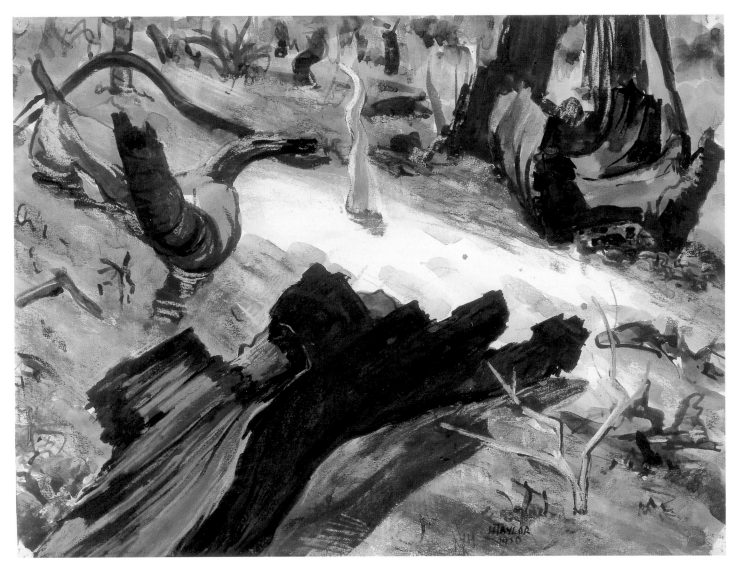

The remains 1950

Visual Experience and Pictorial Structure

The landscape – in particular the Western Australian bush – was the single unifying factor within Howard Taylor's work throughout his career. Over a period of fifty-five years, through observation and recollection, he synthesised a personal motif based wholly on the landscape. Taylor's continuous program of exploration, experimentation and innovation, across the entire range of his production, was an affirmation of the vitality of the landscape tradition as a contemporary idiom. In addition to the continuity established by addressing the landscape, the particularities of locality also underscored his perceptions. Taylor produced his works in only two locations, spending an initial eighteen-year period in Bickley and then thirty-five years in Northcliffe. The works produced in both of these places share equally his sense of isolation and the effects of insulation. These are common characteristics of regional styles, not unique to Western Australia.

Taylor' s continuous emphasis on, and reinterpretation of, the bush locate his oeuvre within an Australian visual dialogue dominated for two hundred years by the impact of the landscape. The persistence of this motif in works produced and exhibited in Australia is a legacy of a European tradition steeped in romanticism. While necessary, a critique of this tradition should not be advanced solely in relation to one individual or locality. This would result in regionalism or provincialism merely as an extension of local personalities. Local individualism is then appropriated as the regional style. While Howard Taylor's oeuvre did not become a locally emulated prototype, his interest in landscape was not atypical within twentieth-century Western Australian visual culture. The comment and analysis in this essay will thus be restricted to Taylor's work without any attempt to see it in terms of a unique regional character. This particularistic method will trace the development of Taylor's production, emphasising both the continuity and specificity of his sources, while isolating his oeuvre as a unique visual manifestation. This is not to deny its relationship to the dominant matrix of landscape-based visual representation within Australia.

Howard Taylor's childhood was spent in an environment that supported and encouraged drawing as a means of communicating and developing ideas. He

described the influence of his mother, Eleanor, as typical of someone with a Victorian upbringing who valued watercolour painting and the arts. Visits to accessible art exhibitions were a regular occurrence.[1] In his youth this encouragement also provided him with assistance in realising two-dimensionally rendered propositions in actual space. His father, Charles Taylor, originally trained as an architect, impressed upon him the importance of design. A high degree of design awareness and attention to the mechanics of how something is built can be discerned in all the projects undertaken by his son. This may appear as an unusual description of growing up in Perth within an ordinary family in the 1930s; in fact, it summarises the two quite distinct influences of Taylor's parents.

Taylor's interest in flight began early, in the 1930s, and was not uncommon among any number of youths at the time. He pursued his interest initially in model-making. This term, however, lacks the specificity adequate to describing his interest:

> *I was always very keen on making model aeroplanes, and in those days it wasn't*
> *a case of just buying ready-made kits that you just put together. I took it more*
> *seriously . . . [and] designed my own aeroplanes to aerodynamic principle[s].[2]*

The *Texaco Sky Chief* of 1936 is typical of his endeavours to construct aerodynamically sound models.

While attending Perth Modern School Taylor also involved himself in rudimentary experiments with photography; he and a fellow student, William Williams, established a darkroom in the Taylor home. Again his interest was in the technical side of things, the main project being the design and fabrication of an enlarger utilising the lens from their disassembled camera. While his interest in photography continued, active engagement with the medium ended in 1937; but the self-reliant and inquisitive experimentation of this period was a hallmark of his work to the end of his life.

When reflecting on Perth in the 1930s and his pursuit of drawing, Taylor made it clear that the support he received was restricted to that of family and friends. His drawings were almost entirely caricatures – usually taking as their subject popular

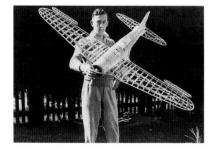

Howard Taylor with
Texaco Sky Chief 1936

personalities of the day – though some were portrait studies of his friends. Recognition of his ability came with the publication of some of his caricatures in **The Sphinx**, the magazine produced by Perth Modern School.[3] Later, the Royal Air Force published one of his cartoons as the illustration on the 1939 Christmas card of the British Expeditionary Forces in France.

Upon leaving school in 1937, Taylor thought:

that it might be an idea to learn to fly, to understand the aviation business more thoroughly, and that was one reason why I went into the air force. And, of course, once I got there I enjoyed flying so much I almost forgot about my major interest.

Howard Taylor enlisted in the Royal Australian Air Force in 1937 for flight training at Point Cook, Victoria, and gained recognition as the outstanding pilot of his year. To continue flying he transferred to the Royal Air Force in 1938, and was subsequently commissioned to a squadron providing air support for the British Expeditionary Forces in France prior to the declaration of war in 1939. On 19 May 1940 he was captured and interned in Germany.

He remained a prisoner of war, spending time in various camps until the end of hostilities. It seems that rudimentary art supplies were provided by both the German army and the Red Cross. Taylor remembers that the Red Cross did a particularly good job, above all in supplying books. There was no formal instruction in the camps, but he remembers five or six internees who had art-school training and were of assistance in his early development. He highlighted the period at *Stalag Luft III* when interviewed in 1970,[4] placing emphasis on the availability of willing subjects to practise his skills at life drawing.[5]

The POW camp drawings produced during this period already show Taylor working across a number of mediums in a single drawing. More importantly, the deliberate and often exaggerated attempts at figurative representation in the early caricatures have been replaced by an interest in anonymous figures in movement. These drawings provide the first concrete record of the intensity of his study. Primarily

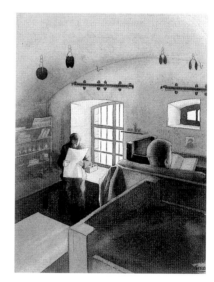

POW camp, Poland c1942
pencil and ink on grey paper
21 x 16.2 cm
Art Gallery of Western Australia

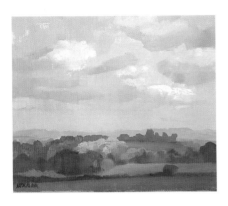

Landscape, Worcestershire 1947
oil on canvas, 20.5 × 25.5 cm ◊
The University of Western Australia
Art Collection, Perth
Gift of Dr and Mrs RK Constable

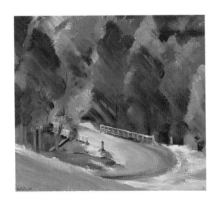

Bridge, Piesse Brook, Kalamunda 1949
oil on canvas, 30.8 × 35.8 cm ◊
Williams Collection, Western Australia

as a means of gaining knowledge and understanding of his surroundings, drawing remained an integral daily pursuit, his preferred medium being pen and ink.

With the encouragement of the camp chaplain, also a Western Australian, Taylor returned to the United Kingdom after demobilisation from the RAAF in 1946 and enrolled as an external student at the Birmingham College of Art under an RAAF rehabilitation program. He described his three years as a student as 'ideal', the situation offering him access to faculty and life-drawing classes for instruction and criticism, but allowing him the freedom to roam the countryside discovering and drawing the landscape.

Howard Taylor returned to Western Australia with his wife, Sheila, in January 1949, settling at 'Aldersyde', Bickley, in the hills east of Perth. He built a studio on the sixty-acre property and remained there with his family until 1967. In 1949, choosing to live in Bickley was a decision to be in the Australian bush. Taylor's life from that point reflected his desire to live in immediate proximity to the land, a choice that had a profound effect on his production and on the pattern and pace of his evolving career as an Australian artist.

Taylor's first solo exhibition – of works for the most part painted in Birmingham plus four POW camp drawings – was held at Newspaper House Gallery in September 1949. It was well received, with *The West Australian* drawing attention to the 'display of pictures that has aroused unusual interest amongst students of art'.[6] *Self portrait* was purchased from the exhibition and presented to the Art Gallery of Western Australia by Mr H Mandelstam the same year.

The paintings in this exhibition revealed the traditional academic nature of Taylor's art-school training, but in a number of them there can be seen evidence of his emerging interest in surfaces as revealed in emphatic directional light. *Landscape, Worcestershire* 1947 and *Bridge, Piesse Brook, Kalamunda* 1949 are typical of his early works in oil. Between his first solo exhibition and the second, in 1951, also at Newspaper House Gallery, his traditional approach was overtaken by the realities encountered through painting in the Western Australian bush:

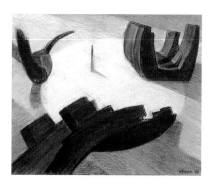

I think the first jolt you get is a change of climatic conditions. The sun is straight up above you; it tends to flatten things out. You miss that half-covered sky or the diffused light that you get in Europe. You have burnt-out stuff in the bush; it's a harsher country altogether, so even if you think like Constable . . . you come out here [and] you can't really paint like Constable.

The jolt affected Taylor's painting almost immediately. Individual elements become isolated within the composition. *Portrait of a blackboy* 1950 introduces his response to the flattening effect he described. The subject is rendered with overt frontality, the xanthorrhoea radiating laterally across the surface.

Unlike *Portrait of a blackboy*, which relies on emphasis placed on the palpable depth surrounding the plant, *Stumps and ash* 1951 emphasises the individuality of each of the three charred stumps, carving them out against the ground with light and shadow. In both of these paintings the subject matter is heightened through the use of a systematic arrangement of information. Despite the differences in composition within these paintings, both evince an architectonic scale and significance.

The paintings exhibited in Taylor' s second solo exhibition, with their lack of naturalistic colour and crisp, orderly definition of form, occasioned the following invitation in *The West Australian*: 'Visitors will be helped to understand the foundations of some modern aspects of painting by studying his work.'[7]

Howard Taylor established relationships between the forms in his compositions with a rigorous abstraction. The introduced symmetry and the colour, while not strictly naturalistic, refer back to the original subject. The direct, orderly brushwork, in contradistinction to the subject matter, activates the surface. The technical requirements of working in egg tempera necessitated a thoroughly planned programmatic approach, and he appreciated this disciplined way of working:

I was always interested in painting techniques . . . I used mixed techniques such as the earlier painters used — tempera with oil and so on — then I got into egg tempera itself, and that taught me much more and backed up my wish for a disciplined way

Study after *Stumps and ash* 1952
charcoal, chalk and pencil on brown paper
41.6 x 51.2 cm
Art Gallery of Western Australia

Self portrait 1949
oil on canvas, 55 x 45.3 cm ◊
Art Gallery of Western Australia
Gift of H Mandelstam, 1949

Kalamunda Road
High Wycombe 1984

of working because it simply demands it. [Tempera] taught me, you could say, almost all I know about colour and the behaviour of materials in a physical sense.

Ordered brushwork across the entire surface can be seen in later works such as *Masked landscape* 1984, where it cannot be explained in terms of the requirements of a specific technique. The ramification of this approach is evidenced in Taylor's increasing emphasis, throughout his career, on tonal value within a restricted palette.

By 1951 Taylor was beginning to establish himself as an artist of some reputation in Perth. He initiated private art classes at 'Aldersyde' in 1950, but within a year had received a part-time appointment to teach painting and drawing at Perth Technical College. He submitted work to all the open exhibitions and art competitions and, out of a sense of obligation, joined the Perth Society of Artists. His membership lapsed within eighteen months.

The recognition Taylor was gaining during this period can be illustrated by the Annual Art Competition and Commonwealth Jubilee Open Art Competition of 1951, where *Stumps and ash* 1951 was highly commended. Despite there being as many as 159 entries, an increase over the previous year that reflected a burgeoning Perth art scene, 'none was considered good enough to justify an award'.[8] A local adjudicator might have had no such reluctance, but James Cook had just come to Western Australia, and he brought with him a more cosmopolitan outlook.[9] Taylor remembers James Cook as an almost singular source of critical appraisal for his paintings during this period.

This was indicative of the restrictions placed on an artist living in Western Australia. Although Taylor never complained about isolation, he was continuously aware of the need for – and lack of – critical appraisal of local exhibitions. There was also the matter of limited access to the greater world of art, and his strategies to overcome this were similar to those of his contemporaries. The major influences upon his work were his recollected experiences as an art student in Birmingham reinforced by visual images seen in reproduction. A key element in Taylor's personal library was

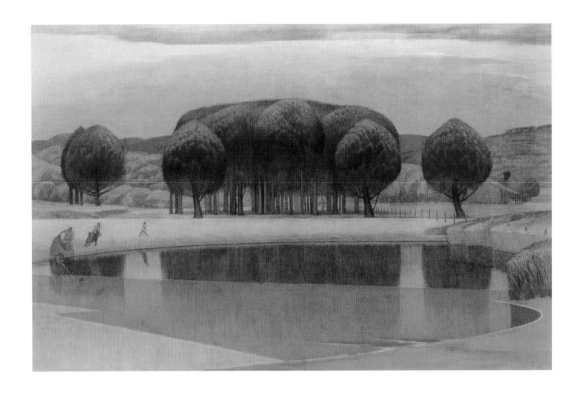

Pine trees 1953
oil on composition board ◊
52 × 81.7 cm
Private collection, Western Australia

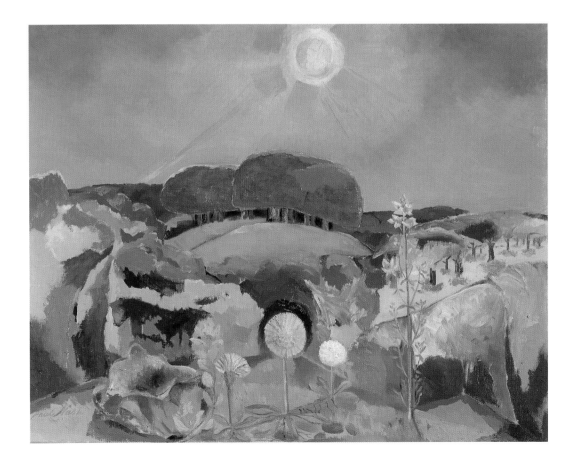

Paul Nash 1899–1946 England
Sunflower and sun 1943
oil on canvas, 71.6 × 91.6 cm
National Gallery of Victoria, Melbourne
Felton Bequest 1952

Trees 1950
egg tempera on canvas ground
on composition board ◊
40.5 × 50.8 cm
National Gallery of Australia, Canberra
Gift of Esther Constable in memory
of her husband, Dr Roy K Constable,
Perth, 1987

Interlocking trees 1956
egg tempera on composition board ◊
50.7 × 35.5 cm
Private Collection, Western Australia

The Penguin Modern Painters series, edited by Sir Kenneth Clark. The books were a common source for many Australian artists throughout the 1940s and 1950s. Taylor augmented these sources with visits to the United Kingdom in 1960 and 1980.

While studying in Birmingham, Taylor had been introduced to the work of Paul Nash and Graham Sutherland, whose paintings were of continuing importance to him. 'Paul Nash: A Memorial Exhibition', organised by the Tate Gallery and the Arts Council for a provincial tour in 1948, provided the opportunity for Taylor to see Nash's paintings at first hand. The effects of this experience can be seen in *Pine trees* 1953 and *Trees* 1950. Nash's *Sunflower and sun* 1943, his second painting of the Wittenham Clumps, Berkshire Downs, which was reproduced in colour in *The Penguin Modern Painters*, and *Landscape of the summer solstice* 1943, from the same series, suggest particular comparisons. The attitude guiding Nash's selection of visual forms was clearly articulated when he discussed *Landscape of the summer solstice* in 1943:

> *The method is ... taking visual facts in nature for visual use in a picture regardless of logic. Objects to me are all the same in the end, i.e. part of a picture, but primarily a pictorial part ... They must be useful pictorially, namely in colour and form.*[10]

Taylor's attitude to the use of natural subjects in his paintings corresponds to the ideas expressed by Nash. To understand Nash's selection process and the similarity in Taylor's approach, a comparison of *Pine trees* 1953 with the stands of pine along Kalamunda Road is useful. It confirms that the degree of stylisation is not solely a function of abstraction: Taylor selects forms in nature that allow for slippage to occur between objective and symbolic representation.

Trees 1950 and *Interlocking trees* 1956 also clearly illustrate Taylor's predilection for the work of Nash. An early painting by the British artist, *The wood on the hill* 1912, was an influential precedent acknowledged by Taylor, as was Nash's later use of 'Object-personages'[11] – elements in his paintings that were based on natural objects he felt had status and personality.[12] This distinction in the representation of objects, both found in nature and fabricated by Taylor, later came to play a more dominant role

within his oeuvre. The design motifs established in Pine trees 1953 can be seen in several works from much later in his career such as Hillside 1990 and Tree island 1991.

During 1955–56 Taylor began not only to make sculpture but also to include three-dimensional objects of his own design as subject matter in his paintings. His first solo exhibition to include both paintings and sculpture was organised in 1957. The sculptures reveal his initial attempts at integrating his background of assembling objects from multiple parts with the magnitude of forms found in the bush:

> When I first started making things I had this background of aeroplane structure —
> you make a plane and you cover it, that sort of thing. But I also found, in looking at
> the fragments of trees around, that I became interested not only in the outer structure
> of a tree but also in its inner structure ... The tree has always fascinated me as a
> unit, from the roots upwards through the trunk to the branches, through the forks
> to the outer flowering top.

Taylor's response to the description of volumes, in both the paintings and sculptures, consists of exposing them as intelligible structures. An early example is the stick-insect subject, first developed in Creature 1955. The conoidal form of the subject, comprising both a cone and a suggested spiral movement, establishes its palpability through the implied spatial extension of a basic tripod structure. Creature can be considered as the initial emergence of what Taylor develops in later works as 'forest figures'.

The first use of the 'stick insect' as a subject for a sculpture occurs with Stick insect 1958. This work retains many of the characteristics introduced in Creature, despite the cone shape being replaced by a central cylinder with projections. The stick-insect sculptures are basically volumetric forms, the volume being maintained in each case through schematic approximations. The paintings and sculptures from this period are informed by a particularly British attitude to the surrealist object, with its penchant for a found object extracted from the landscape.[13] Taylor's continuing interest in movement and flight also re-emerges at this date:

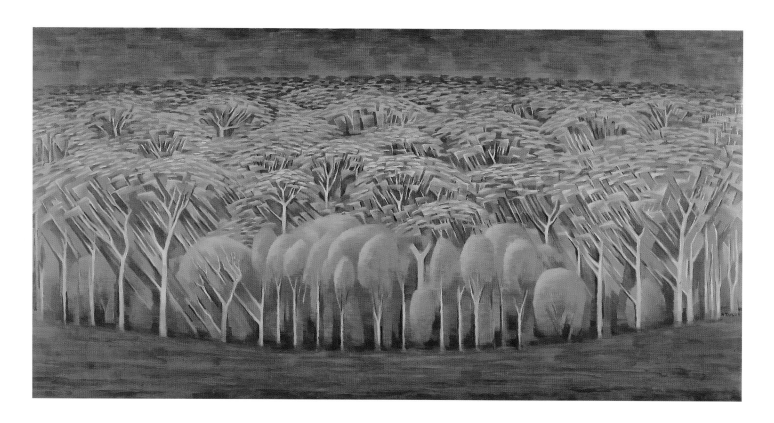

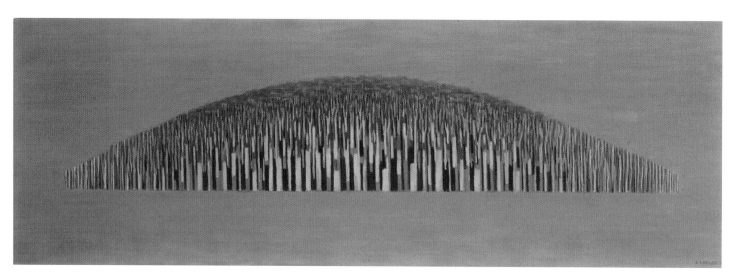

Movement became highly important to me — visual, pictorial movement. Not the brush, not the hand, not the expressive active movement, but the built-in pictorial visual movement. I think that still is an interest with me.

Flight of a magpie, *Bush structure — flight* and *Flight* are definitive works, each a singular encapsulation of the synthesis of Taylor's landscape style. In these works — developed concurrently in 1956, as is evident in the studies — Taylor combines a subject drawn from nature with his interest in visual movement. He utilises a visual pictorial movement that is maintained not by the gestural treatment of each subject but through the use of forms with implied directional indicators, for example spirals. Unlike his earlier works in tempera, the entire composition maintains a close connection with the perceived landscape while remaining entirely separate from any mimetic consideration:

> *I painted* Flight of a magpie *with the figure/ground movement supported by the internal action of movement and space . . . then* Bush structure *where the bush landscape was taken with movement between the trees as the main action . . . Interest in fore and aft movement go to aircraft structure and related behaviours in the sky — hence* Flight. Flight *is more descriptive and literal of flying and missiles and sound booms . . . but clearly follows on from the previous paintings in exploring space in three dimensions.*[14]

These paintings, as seen earlier in the relationship between *Creature* and *Stick insect*, also led to sculptures exhibited in the same year. Additionally, sculptures were often used as still-life subjects for paintings, introducing a fluidity within Taylor's oeuvre, with images appearing in several mediums. *Skeletal remains* 1958 and *Colonnade study* 1995 illustrate the extent of formal malleability Taylor embraced throughout his career by using his own works as subject matter for subsequent paintings.

Flight of a magpie 1956
egg tempera on composition board ◊
61.2 × 122 cm
Destroyed by the artist
Second version painted in 1996

opposite

Hillside 1990
oil on canvas
92.5 × 182.6 cm
The Holmes à Court Collection,
Heytesbury, Perth

Tree island 1991
oil on canvas
66.7 × 198.5 cm
Kerry Stokes Collection, Perth

Untitled 1956 (destroyed)

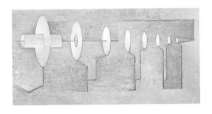

Study for *Skeletal remains* 1958
pencil on paper, 24.5 × 19.8 cm
Skeletal remains 1958
oil on composition board ◊
75.5 × 136.5 cm
The University of Western Australia
Art Collection, Perth
Gift of Dr and Mrs RK Constable

This fluidity – renovating images for reinterpretation across both medium and any number of years – gradually became a dominant aspect of Taylor's oeuvre. He rarely developed subjects naturalistically, but elected to continually test different ways of manifesting the majesty, power and animation he found in the landscape. His avoidance of naturalism allowed him to return again and again to the same subject and specific theme. The resulting works, always intimately dependent on perceived natural environments, continuously explored an 'intellectual approach to abstraction, not abstract but synthetic'.[15]

The decade prior to 1960 was a period of intense activity for Taylor, with frequent participation in exhibitions. His commitment to teaching throughout his time at Perth Technical College led to the evolution of many significant course developments, the most important of these being the development of his own colour theory:

As time went on I found that I'd like to have something more concrete and tangible to teach than just emotional or personal encouragement. I preferred to have students that got on with their work and have no relationship with them at all ... which led to 'What do I teach them?' ... I tried to lay out a study, an intellectual study that would help you actively in the simple business of real pictorial work.

When I started teaching I only had a few days – I didn't want to become a teacher on a full-time basis. When I found that I could work with architects ... it seemed like a good idea to me simply because it appeared to be a more useful occupation than exhibiting paintings in a gallery, which didn't sell very much anyway.

Taylor's next major solo exhibition was in 1960. In the same year he also undertook his first major public commission. Over the next twenty years his philosophical commitment to public commissions – as the most direct approach towards integrating the artist with a broad non-specialist audience – was unfailing. The number of publicly commissioned works increased while his involvement with solo exhibitions declined. Taylor's immersion in these public projects is probably

more responsible than any other factor for the local mythology about his reluctance to exhibit. He maintained his relationship with the Skinner Galleries for over fifteen years, and his exhibitions, although infrequent, marked the culmination of periods of intense activity. While several of the public commissions reflect a considered response to rigid design briefs, they were opportunities to address an audience in a scale and range of mediums not previously available:

> *I was feeling at that period that public commissions were a useful way of . . .*
> *it sounded idealistic, but it seems a useful way for the artist to be employed and a*
> *useful way in which the public can see art, because normally they don't see it or*
> *ever think about it . . . That interested me considerably. It does work; in fact I still*
> *believe in it.*

The degree to which Taylor felt the commissions were successful often reflected the scope available within the architectural brief. Bush group 1961 evolved into consulting on interior fittings, the floor, lift bays and reception furniture. Another contract, let by an architectural firm to the artist for interior colour coordination during construction of the wards at Princess Margaret Hospital in 1969, evolved into five interior relief murals. Recognition of Taylor's ability to tackle projects that might appear tangential to the pursuits of an artist led to some of what he considered his most satisfying and engaging design jobs. His motivation throughout was an interest in being usefully involved in a project as an artist.

Throughout the first period of Taylor's most active engagement in publicly commissioned work, roughly 1960 to 1967, he maintained both his notebook studies and his painting as contiguous pursuits. These paintings reveal more immediately their landscape sources than those produced in the later part of the 1950s. Technically, he stopped using egg tempera entirely, preferring the immediacy of effect possible with oil. He also experimented with pigment suspended in PVA.

His major innovation during this period was the introduction of an actual third dimension in his paintings. The works occupy the uneasy zone of being perhaps too

Relief landscape sections 1963
oil on shaped panel
32 x 67.5 x 2 cm
Estate of Howard H Taylor

painterly to be strictly considered wall reliefs and containing too many facets to be referred to as shaped paintings. *Relief landscape sections* 1963 is a good examples of the complexity he was striving for in his representation of the landscape.

Many were based on an introduced symmetry in the composition, and prefigure his work of the 1980s and 1990s. Symmetrical design was important to Taylor, emphasised in particular periods or works, but never entirely absent in any period:

> Often paintings reduce down to a perfect split bi-part thing, with a central axis and something on either side. I feel that if you can get something happening out of a symmetrical design you've got movement — an action with an anchor as it were — and it can be more powerful than just movement.

A comparison of Taylor's early paintings in tempera with his late work reveals many similarities, including the disciplined organisation of both the composition and its execution. The works produced during the 1960s highlight his commitment to using the bush as subject matter. He described the transitional nature of the paintings produced during the 1960s as follows:

> I came to a stage, painting in tempera, where I began thinking that I'd been using an outmoded technique. There is a lot of tedious work involved in tempera and I was getting a little bit impatient, although I could balance it up with more direct painting and drawing. I did in the end feel that I ought to oil paint, and at that period of course there was a lot of interest outside in more gestural painting, more expressive painting. I think for a while I succumbed to that weakness, but then I was able to steer my oil painting to a more organised approach, sort of akin to the tempera painting that I used but working in a freer way.

Taylor relocated his home and studio to Northcliffe, in the south-west of Western Australia, in 1967. When re-establishing himself there, the influence of his previous commissions clearly affected his initial decision to concentrate on sculpture. The resultant works vary dramatically in scale, reflecting the two quite distinct working

environments available in Northcliffe. The timber sculptures were constructed outside without the constraints imposed upon the small works, which were produced in a fairly restricted studio. The wood at hand, not previously available in such quantity, reinforced his choice to work at sculpture, virtually exclusively, towards an exhibition.

The result, his first solo exhibition devoted entirely to sculpture, was exhibited at the Skinner Galleries in 1970 and did not go unnoticed. Although scheduled to be on view for just one week in December, it was installed in the grounds of the University of Western Australia for the entire period of the 1971 Festival of Perth.

The works exhibited in 'Howard Taylor 1970' reveal a curious dichotomy. In the carved and constructed works, utilising local timber, the basic requirements for air-drying and curing timber provided a predetermined range of formal options. The hollow coring of the timber in cylinders, which were then used in many of the sculptures, underline Taylor's innovative response to a technical necessity. The other sculptures presented an almost antithetical solution to the consideration of form. They are primarily thin coloured skins divorced from any structural considerations of the materials or the procedures used in their fabrication.

Taylor extended both of these approaches in the ensuing decades. The coloured skins became increasingly less materially based, providing an opportunity for large-scale painting to again develop within his oeuvre. Colour increasingly became an epidermis covering a skeleton; accordingly each skeleton required a different manner of isolation and illumination. The timber works initially accommodated colouration as well, the coloured surface treatment ordered by the structural determinants being visible in live wood.

With *Way through* 1977–78 he returned to a design grounded in technical knowledge of the subject matter as material. This work resolves many formal problems stated more than a decade earlier. Both radial cracking – branching out from the core – and circular cracking around the circumference are interests apparent in both the paintings and sculptures over the preceding three decades. *Way through* is equally the culmination of Taylor's interest in structural design. The entire work rests on a steel

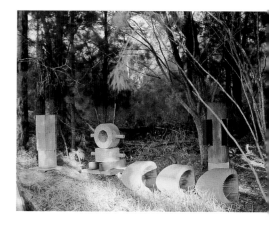

Hexagonal column, Turn about, Spiral and *Precision*, Northcliffe 1970

sub-frame to compensate for the inevitable shrinkage. This allows for the continuous realignment of each of the wooden elements. Taylor took advantage of this to adjust the work on subsequent visits to Perth. It was completely rebuilt in 2001 – and again he worked with his original collaborator, his son Brett.

The continuous process of re-evaluating ideas and finished works, sometimes over a period of twenty years, can be seen most readily in *The black stump* 1975. Now located on the campus of the University of Western Australia, it was the most prominent public sculpture in central Perth in the 1970s and 1980s. *Stumps and ash* 1951, already an abstraction synthesised from notes first recorded in *The remains* 1950, reveals the constituent architectonic elements of *The black stump*. This unrelenting presence of the bush as Taylor's source establishes a continuity that defies analysis premised on a linear, progressive model. Over gaps of perhaps twenty years he elects to refocus his attention on a subject, usually from the landscape, developed and resolved in a preceding work.

For Taylor painting re-emerged as his major preoccupation over the last two decades of his life. The physical supports for the paintings often took on a three-dimensional status indistinguishable from sculpture, but the prerequisite imposed by the painted surface always directed the construction of the support. Early works from this phase drew enthusiastic applause from the British painter Bridget Riley on her brief visit to Northcliffe in 1977.[16]

This rekindled interest in painting involved him in extended series and ambitious experimentation across a range of projects. Initially, in 1976, he painted with oil on a very small format. These works have an immediate affinity with the notebook studies, so much a part of his daily routine of observation in the bush. Taylor commented on the uncharacteristic nature of these paintings within his oeuvre:

If your main consideration is planned, disciplined work, it is quite nice to break away from it ... And in this case, with those little weather jobs, I found [myself], for the first time in my life, becoming able to accept the subject as a subject and not just as something that I can make a painting out of.

opposite

The black stump 1975
polished concrete and mosaic
457 × 500 × 500 cm
Commissioned by AMP Fire
and General Insurance Co. Ltd.
St Georges Square, Perth.
Relocated to The University of
Western Australia Art Collection
Gift of the AMP Society, 1990

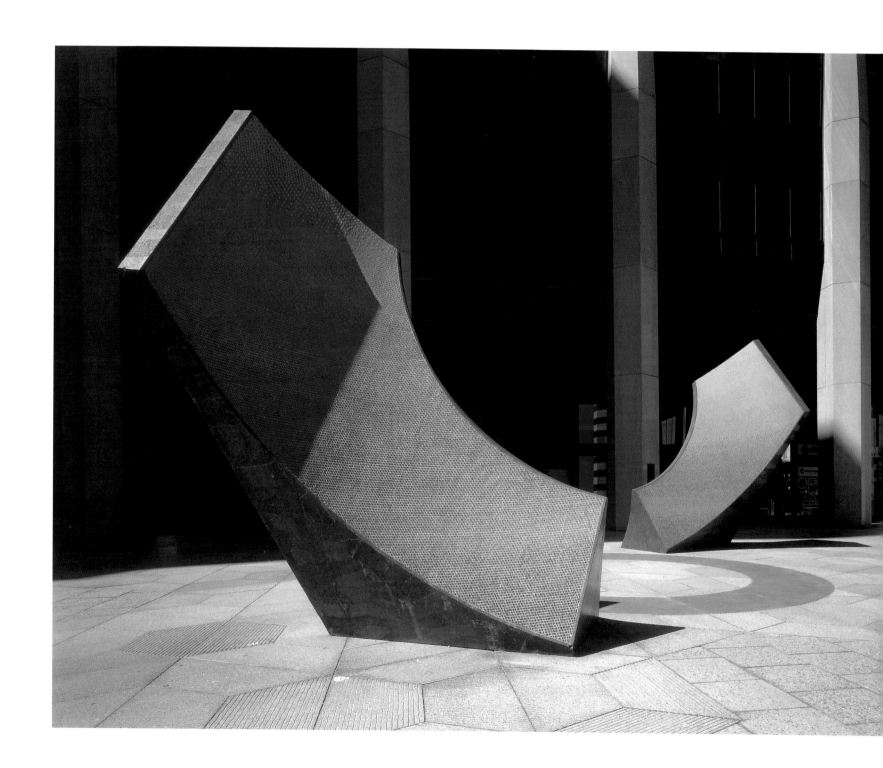

Immediately following this period Taylor began to work on an increased scale and introduced shaped three-dimensional supports, first seen in the shaped relief paintings exhibited in 1963. The majority of these works are attempts to stabilise, for reflective consideration, the fleeting effects of light observed in the bush.

Over his last two decades this interest in painting led to an unrivalled period of progression and experimentation. The bush continued to reveal itself with a freshness reminiscent of his work of the early 1950s, shortly after his return to Australia.

Taylor adopted several strategies in his later work to effect the required stabilisation of perceptual discrepancies uncovered by light. Most of the paintings utilise a binary composition, perhaps a simple rectangle upon another larger rectangle. The resultant figure/ground relationship is then used to support the description of light observed in the bush. This might be looking at a leaf into the sun against a blue sky. The colour of the leaf would occupy the inner rectangle or figures and the colour of the sky the outer rectangle or ground. The same observed conjunction of the leaf and sky established the figure/ground relationship in the painting.

Concurrently with this, in the 1980s, Taylor also began to construct three-dimensional paper models to be hung against his studio wall and serve as subject matter for painting, again with a binary composition, but this time to record the specific conditions of illumination in the studio. This series was his major preoccupation in the early 1980s, and became the source for numerous large scale and shaped paintings developed from 1982 to 2001. The obvious three-dimensionality of these paintings continued to explore figure/ground relationships when installed, only increasingly incorporating the context of the display environment as an integral component of each work. Taylor continued in all of his paintings to seek out a design problem and use it as a support for the representation of his observation in the bush:

> It depends on that disciplined approach again. It's through design that you get your final result, and you also get involved with light as an active member of the game. Just recently ... I have been trying to avoid the vagaries and uncertainties of light

when you present these shaped things, and the solution there was to ... make it look shaped and fix the situation as far as the light goes, but that brings in — it can bring in — another element which becomes part of the game too. Well you could say in all cases it's related to landscape in some way, or my experience with landscape ... I've been approaching landscape in a direct, almost naturalistic way with my spontaneous drawings and little paintings. Assuming that what you end up with has to have some sort of significance, you can move into [it] from that retinal naturalistic way and gradually build in more meaning until you end up with something that is a statement. You can also come in the other side, and start off with a few geometrical shapes, get some interest going in the way of movement, contradiction ... and lead it towards landscape, to end up with a significant comment on landscape. To go back to the other one, you can come in from the naturalistic way and refine it and reduce it and end up with an abstract work, but you can start with an abstract work.

Howard Taylor directed his vision towards the Australian bush over fifty-five years, using a notebook to record daily occurrences. He sought to reconcile the barely perceptible camouflaged nuances of the karri forests that dominated his environment. This search focused continually on the process of differentiation. The emphasis upon differentiation developed over the years by studying, in an almost empirical manner, observed visual discrepancies. He nurtured an acute awareness of the continuous change evident within the forest. The cycles may be of hourly, annual or even longer duration, but for him this pace requires observation, assessment and a visual record. Howard Taylor was much more than solely an observer of the bush: he was an active participant, engaging his selected subject as an inventor as much as a recorder.

Richard Woldendorp born 1927
Karri 1988

GARY DUFOUR

Originally published in *HOWARD TAYLOR Sculptures · Paintings · Drawings 1942–1984*, Art Gallery of Western Australia 1985.

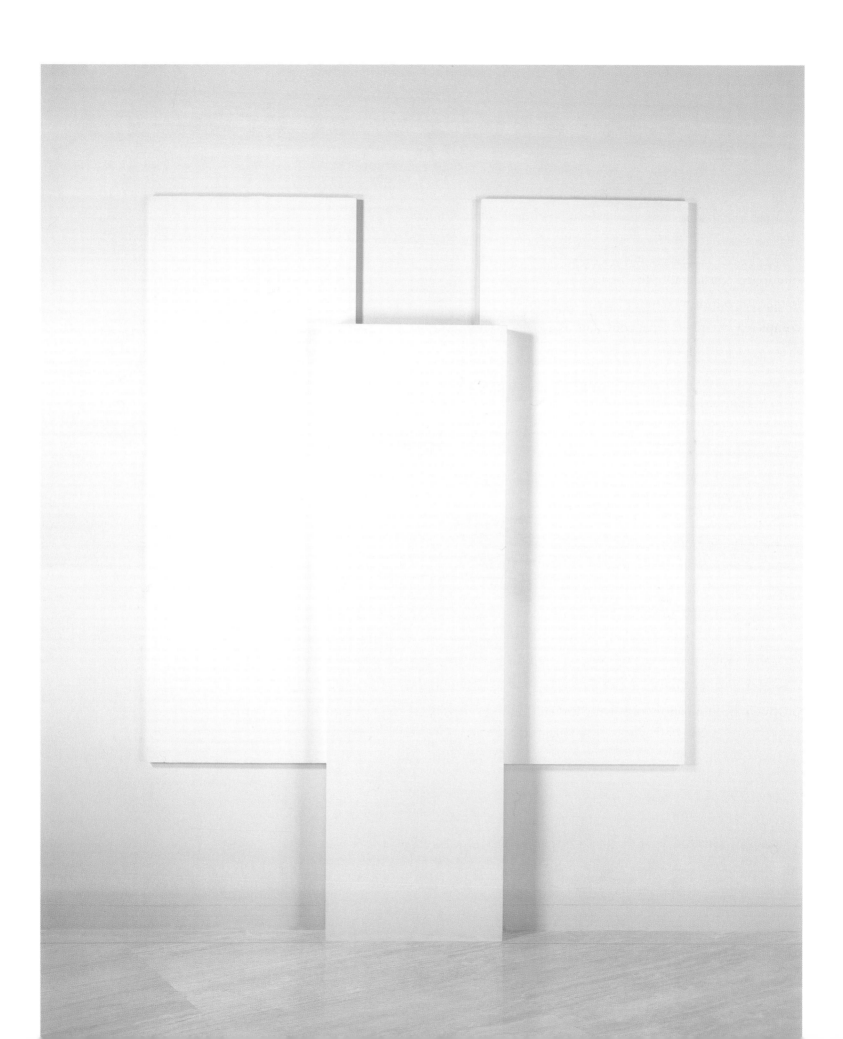

In a Silent Way

The increasingly visual nature of our culture has not necessarily taught us how to look. Awash with images, we are used to instantaneous information, recognisable imagery delivered at maximum speed. While the functions and intentions of art have multiplied considerably, the best art still asks us to see differently, or at least to look longer. Art requires attention, a sustained process of discovery that never, ultimately, completely deciphers what confronts us. No matter how much we might know, something remains hidden, fugitive, the work always demanding what Alberto Manguel has described as 'reaction, translation, learning of some kind – and perhaps, if we are lucky, a small epiphany'.[1] While Manguel's is an unashamedly romantic position, his argument holds. We are always looking for small epiphanies in art, and one may well be found in the work of Howard Taylor, who produced paintings and sculptures that demand sustained attention if we are to come to understand his singular vision of the Australian landscape. Taylor's works are classical in conception and modern in intent, each one pared down to the barest essentials. They communicate through silence, enabling a myriad of readings.

Silence is integral to Taylor's art. His work is derived from the landscape, in particular the Western Australian forest where he lived, yet it is not a landscape of squawking birds or rushing rivers. Taylor's is a rigorously synthesised landscape based on the analysis of changing light and weather conditions, the life cycles of the karri trees that surrounded his studio, the sensations of driving through the bush or along the coast. It is the landscape as experienced by an artist living within it. This subject provided the foundation for solving fundamental problems of art-making, a quest that consumed Taylor for more than fifty years.

> *I've been obsessed for a long time by the notion of opposites in nature ... I feel a great need to try and understand and explain, to tie the ends together, to get opposites to agree. I'm interested in the different ways that things can be seen and the way an artist can get a lot to happen with a refined and simple structure.*[2]

To me, this quote encapsulates Taylor's approach and his unusual position within

opposite

Winged figure 1995

53

Australian art history. His search for an essential unity and order underlying the apparent unruliness of nature resulted in an art that pulls between opposing forces on numerous levels, creating richly rewarding visual and conceptual tensions. Despite their formal simplicity, his works are irresistibly complex. Moving between painting and sculpture, figure and ground, literal and abstract, material and conceptual, local and global, Taylor's art eludes definition.[3] It articulates ideas concerning perception, the mechanics of vision, the relationship of work to site, and the physical and conceptual interaction between artist, artwork and viewer, all arising from the artist's core interest in the visual phenomena he encountered in his particular corner of the world.

To look in depth at Howard Taylor's work is to experience the distillation of a lifetime of careful observation, experimentation and continuous refinement of the essential visual apparatus to engage the world and convey new meanings from experience. It is not a rapid process: his art takes time to reveal its riches. In the early days, Taylor's analytical approach was rare. A review of his 1960 exhibition at Skinner Galleries in Perth stated that 'those willing to return and study Howard Taylor's art will find in it matters for appreciation and delayed satisfaction rather than immediate admiration'.[4] More than forty years later, the point remains relevant. As Lynne Seear wrote in the 2002 Asia-Pacific Triennial catalogue, 'We have to look hard [at Taylor's paintings]; and the harder we look, the better are our chances of breaking through old conceptual habits and achieving the fresh, accurate vision Taylor has developed.'[5]

Both responses in their own way recall Rainer Maria Rilke's letters on the work of Cèzanne, in which he wrote that 'it all takes a long, long time. When I remember the puzzlement and insecurity of one's first confrontation with his work, along with his name, which was just as new. And then for a long time nothing, and suddenly one has the right eyes ...'[6]

By now Taylor has been nationally recognised as a major artist with a compelling vision, yet for viewers of contemporary art, with access to a wide range of modern and postmodern art movements, his work remains resolutely difficult to place. Where, for example, can we position Taylor within the Australian landscape tradition? His

presentation of landscape as immersive experience could perhaps be compared to the work of John Olsen or William Robinson, although their landscapes are bursting with life and noise. In the silence of his work he is closer to Fred Williams, nine years his junior, who also utilised modernist strategies in his landscape-based works.

Like Williams, Taylor reorganises our perception, making us more aware of what – and how – we are seeing. As Ian Burn noted, Williams's calligraphic representation of the Australian landscape required the viewer to draw on external visual experience rather than what was represented within the artwork itself, 'making perception become a more critical and self-conscious act'.[7] The horizon, for example, became with Williams both a formal and a spatial element while also referencing previous landscape traditions. It also reaffirmed the classic position of an onlooker gazing across the landscape, unlike Taylor's close focus on elements within it.

Taylor's work rarely presented vistas, as in more conventional Western landscape painting, preferring equivalence to description. Even the more naturalistic landscape sketches, such as his 1976 series of small oil-on-board paintings, focus on climatic conditions and phenomena such as rainbows and cloud formations. He further avoids the illusionism of a window onto the world by extending the paintings with hand-made painted frames, incorporating them into the work and so reminding us of their object status.

Little seems to be gained, however, by drawing such comparisons with other Australian landscape artists or trying to define a unique regional character. There are no 'school of Howard Taylor' painters following in his wake. The artist steadfastly followed his own path, and his work sits outside particular schools or movements, however much it might seem to intersect at certain points. In this, he could perhaps be seen alongside artists such as Max Meldrum or Clarice Beckett, Rosalie Gascoigne or Robert MacPherson, in his quiet evocation of specific landscapes while developing a personal visual language, drawing on the materials at hand.

While Taylor was aware of developments in art both locally and internationally, he chose to work alone, sustained by his own research and the lessons learnt from

Fred Williams 1927–1982 Australia
Untitled [*Trees in a landscape*] 1957
oil on board, 94 x 88.5 cm
The University of Western Australia
Art Collection
Tom Collins Bequest

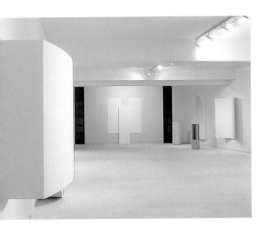

Heavy object, Winged figure,
Four part unit, Contracurve,
Internal cylinder and *No horizon*
Galerie Düsseldorf, Perth 1995

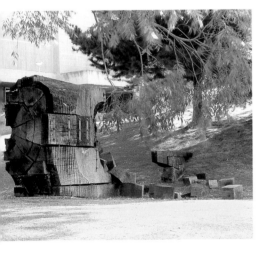

Way through 1977–78
karri and zinc-coated steel
250 × 1028 × 519 cm
refabricated by the artist
in 2001
Curtin University Art Collection,
Perth

painters of the past. Like so many Australian landscape artists, he had the urge to grapple with the particular conditions of this country: the intense, flattening light, the ancient trees, the prevalence of fire. On returning to Perth after ten years in Europe, he was struck by the great difference in the light and climatic conditions, and consequently set out to 'paint Australia'.[8] It was an approach without romanticism or nationalism – more a way of engaging with the place in which he and his wife chose to live and work, a place that allowed independence, tranquillity and endless source material. Taylor's work traces the cycles of time, marked by the sun and moon, and of birth and death, heralded by rain and bushfires. Thus is its relationship to place both intimate and profound.

While Taylor was largely averse to spiritual or symbolic readings of his work,[9] his recurrent vocabulary of motifs, such as discs and winged figures, create a visual poetics that, when they are installed together, resonate deeply from one work to the next. Taylor conceived his exhibitions in their totality, building an experience for the viewer that was nuanced by a highly sophisticated understanding of the conditions of gallery display. For example, *Light source reverse* 1994 was 'intended to be seen on a light neutral wall, illuminated frontally with suffused light. The figure is given slight relief and large scale to stand up to any vagaries of exhibition.'[10] This work was produced for the 1995 exhibition 'Howard Taylor: Constructions–Paintings–Drawings–Maquettes', held at Galerie Düsseldorf in Perth. Launching the gallery space – which was designed in part to display Taylor's work to best advantage – the exhibition was almost entirely in monochromatic white. This was the artist at his most minimal, developing his inquiry into forms in space with a commanding clarity. Looked over by the penetrating sunspot of *Light source reverse*, which faced the angelic white *Winged figure* on the opposite wall, the sequence of human-scale constructions played between two and three dimensions across the walls and onto the floor, an exquisite demonstration of formal and conceptual coherence.

Taylor's awareness of the reception and site-specificity of his work was informed by his many years of working with public sculpture. Many of these works have been

relocated or disassembled, causing the artist considerable distress and inviting the comment that he 'would prefer [them] to be destroyed. Don't move them, get rid of them.'[11] This dedication to the particularities of how his works are viewed indicates the importance to Taylor of their status as objects operating in the world. His art is functional – if art can be so – in the very best sense of the word. It is designed to convey the painter's vision, to communicate the experience of looking as clearly as possible. This humanistic approach also informed Taylor's longstanding commitment to public art and its access to broad audiences.[12] His works are produced to the highest standards of craftsmanship, their forms, supporting structures and surfaces immaculate. It is work built to last, but work that always exists for the present: that silent moment of interaction with the viewer.

Manguel quotes Samuel Beckett, from *Molloy*: 'To restore silence is the role of objects.' I like to think that Taylor also felt this way, with his attention to objects clearing a space to look with minimum distraction.

RUSSELL STORER

In a Silent Way is a Miles Davis album from 1969. The title track, written by Joe Zawinul, was inspired by the serenity of being at his childhood home in Austria. The album is considered a turning-point in Davis's career.

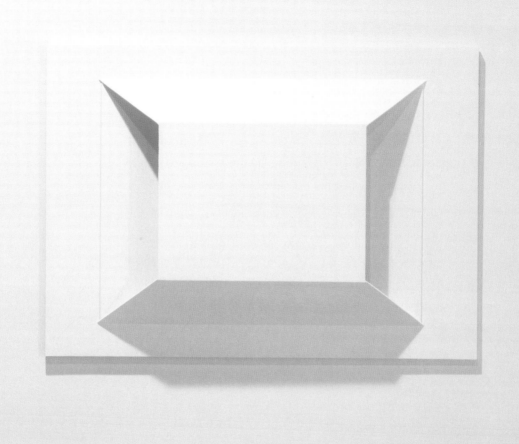

Interview

Howard Taylor interviewed by James Murdoch in 1986
for the Australia Council Archival Art Series

I think your childhood is very important, and I look back on mine more as I get older. So my early days in Adelaide now seem much more important than I ever thought they would.

My grandfather had a property – orchard, vineyard – on the Torrens when I was just a kid, and that was very interesting. I used to help him pick fruit, go to the market, all that sort of stuff. I've got very fond memories of that part of my life. Perhaps the earliest memory I have was when my father took the family up to Booleroo Centre. He was in the church and had a stint to do up there, in a pretty desolate part of South Australia. It's just flat trees and dead cattle. That made an impression on me: how desolate country can be. I've often thought that it's so very different from the hills – the Mt Lofty Range – and so very different again from the Torrens River area, with the orchards. It's such a dry place, South Australia. The heat and the dryness made quite an impression on me – and the dust!

I thoroughly enjoyed my country contacts. My one regret is that I spent so much time in the suburbs. I would have preferred to be in the country somewhere. When we came across to Perth we were again in a suburban situation, but happily I made friends with a bloke who had a property up in the hills, and we used to holiday up there. I think that was my first contact with anything resembling forest country – the Stoneville and Darlington area. That was when I was at Perth Modern School, which was quite a valuable period inasmuch as I met a wider variety of people than I had hitherto mixed with. I rather blotted my copybook at the school because I got so interested in sport – I found I could run a bit faster than other blokes and kick a football better than most, and so on. My studies rather suffered. They were also buggered up a bit because I was selected for the Air Force in my last year and I felt, well, why should I worry about getting my finals?

I really took to flying, partly because I had been very interested in model airplane making and aircraft design from the age of about twelve. As I got more involved in it I found that you could actually design airplanes on approved principles – aero-

opposite

Untitled [*Construction on the wall*] 2001

dynamic principles – and that really intrigued me. The school was of some benefit to me there because you had quite complicated formulas, and I was happy to be able to work mathematically, draw, calculate, design on a drawing board then make – make the job and fly it, and see how it went according to your design. I think the ones I enjoyed most were the gliders, simply because they soared so beautifully. And if you were lucky – if you got an up-current – they just went up, like a hawk, out of sight. That gave me a lot of satisfaction.

I thoroughly enjoyed flying – one of the happiest periods of my life really. I transferred from the Australian Air Force to the RAF, but then World War II came along and sort of spoilt my fun. However, you're committed to do what you're supposed to do, and they trained you very well, so you said yes. The Air Force was backing up the British Expeditionary Force in the early part of the war, and I was brought down over Alsace-Lorraine when the Germans broke through in May 1940. So there I was in prison camp. It gave me time to reflect, which I hadn't done previously. My five years in prison camp were a most important period in my life artistically, because that's when I accepted the fact that I might head that way. I spent a lot of my time drawing. There were a few blokes there that had been to art school, and they were helpful. All in all it convinced me that was what I wanted to do after the war.

On getting discharged I managed through a fellow prisoner of war – actually the camp padre – to organise a two-year study grant in Birmingham. Most Australians went to Melbourne or Sydney for their rehab training, but there I was in Birmingham as a sort of 'odd bod'. Unlike the British ex-servicemen there I wasn't taking a course, and the benefit was that I could use the art school just as I wished. I could attend life class as I wanted, and some quite good blokes there could help me, but I spent as much time out in the country painting as I did at art school. And I still got my three quid a week.

By that time I had married. I'd met Sheila in London while I was waiting to be discharged, came back to Australia, got out of the Air Force, went back to England

with my study grant assured and we settled in Birmingham. We had our first child and I was happy as could be.

Birmingham wasn't too bad because it was only two hours from London. You'd catch a train in the morning, spend the day in London and come home. Birmingham also had quite a good gallery and library, so it wasn't a bad situation. I suppose you could say that's where I learnt to cope with the image-making problems of painting – I could paint a landscape that looked like a landscape and had some sort of feeling about it. I have always been a fan of Constable, and I could see lots of Constables and Samuel Palmers and works by other artists involved with nature, and they became quite important to me. So landscape seemed to be my direction when I came back to Australia. Of course there was a very marked change from the landscape I'd become used to, and I was most impressed by how the sun flattening everything out. No clouds, burnt trees – quite different.

Painting the Australian landscape involved a big change for me, and another change was that I soon got more involved in tempera painting. Of course if you paint in tempera you become engaged in a highly disciplined technique. You've got your dry pigment, you have your egg, you have your laboriously prepared panel – you've got to plan right from the beginning. In fact you are designing – designing the whole painting program right from getting your raw material together. I put that down as one of the most important periods of my life. I painted for up to ten years in that vein and learnt more about the technique of rendering pictorial qualities than I had from oil painting, simply because you had to plan.

But I gradually became a little bit unhappy about painting in an old technique and taking a month to do one painting. It didn't seem to suit the pace of today. So I gradually drifted into an easier approach, a mixed technique of tempera and oil, which I continued with in a disciplined way. It's a freer way if you want to paint like Titian – it's a mixed technique but it's a very free mixed technique. If you want to paint like a Flemish painter you're painting in a more disciplined way. And that was my inclination.

A lot of the tempera paintings were worked out in quite a detailed sculptural sort of way, so you could take a painting and make a sculpture of it. That's where the sculpture started coming into my painting. It led me to actually make things. Some of them were painted because I liked the colour-plus-sculpture combination, so I found myself in a situation where painting and sculpture were mixing together. At that stage, early on, I could make a piece of sculpture and then make a painting of it. It meant you shifted to a different way of thinking, because you're going into a two-dimensional surface but you're concerned with space and structure still. That's something that's been going on all my life really – the interrelation of sameness, of sculpture and painting, in respect to nature. It all comes back to nature. I have never been very interested in the figure.

As to my earlier exhibitions, I remember the very first one taking place at Newspaper House, not long after I had come back. They were mainly landscapes, and most of them were English paintings I'd brought back with me. I also included Australian scenes because I had already been here for a year and it made an interesting contrast. I followed that a couple of years later with another show at Newspaper House – mainly Australian work, including my early tempera work. It was quite a long time before I had another one because I wasn't all that fast a worker. I didn't like working for an exhibition; I preferred to get a body of work behind me and then say, well, I had better have a show and see if I can make a few bob. And speaking of making money, it was about that time that I started teaching. It was quite a useful period too, because if you're going to teach you've got to find out something about what you're teaching. It helped me considerably.

After teaching for quite a few years I got somewhat discontented with the rather dormant art scene in Perth, and I wasn't all that happy with my own work, so Sheila and I took a trip to England for six months. We saw as much as we could with the resources we had, doing a short trip to Paris, Belgium, Holland and back to England,

looking around the galleries. In fact I quite saturated myself with paintings. And I came to an interesting conclusion: that the most important thing I should be concerned about was honesty in my relationship with nature and with painting – not style, not any sort of impressiveness to suit a show. Going back over the centuries you find so much fashionable work that is important now because it's a bit old and somebody's name is fairly important. I much preferred a dinky-di painter like Constable, say, in contrast to Turner. Turner was always too theatrical for me. Constable strikes me as an honest painter; same thing with Samuel Palmer. The experience reassured me that I should take time and not force myself to exhibit too regularly unless I was completely happy with my work. That was one important result of the visit; another was that on my return I began to escape the tedium of teaching to take on public commissions.

The early ones were paintings; later on I moved into sculptural projects. I enjoyed them because they always present big problems, and I have found that having a problem to solve is quite an incentive. It's not only an incentive; it's an aid to creative solutions that have depth and something profound about them. I found myself recollecting what I had done in tempera painting. Pictorial work has an infinite number of things pushing and pulling, and your job is to order it in such a way that what you end up with has unity and some significance.

With my architectural work one thing led to another. I was lucky enough to have a firm ask me to do some work for them, on quite a big scale, in the Fremantle Passenger Terminal. It was a proposition I wasn't completely enchanted with – flora and fauna for visitors getting off the ship at the port – so I had the problem of doing something I didn't really want to do. I came up with something that gave the architect and the client satisfaction, and it gave me the satisfaction of solving the problem it had presented.

I found my work with architects most interesting. In the early stages, around the 1960s, it was rather difficult because it wasn't a practice that was well established

here. A few buildings had small things on the walls outside – something decorating the building in an ornamental sort of a way – but there was no serious attempt to combine the work of the architect and the artist. This was partly because it was not considered appropriate to pay an artist enough money to turn out a major job.

I was lucky with the first architect. He was quite considerate, and also he knew what would suit the client and what wouldn't. That first job established real work as being feasible on a big, big scale, which led to quite a bit of other work with the same architect and with another big firm. One of my early sculpture jobs, which is lost now because they cleared the front of the building for some reason, was quite successful and established the fact that sculpture could play its part with a building and enhance its atmosphere in the same way that paintings could. I found this all very intriguing because it's quite a bit of a worry when you take on a big job. You're immediately involved with the budget and with what industry has to do for you because you can't do it all. If you're working in concrete you can't establish a concrete yard with great big overhead cranes and so on, so you go to industry. If it's metal work of some intricate kind, you've got to go to a metal worker, and so on. I found this rather exasperating in some ways, but it was quite a good experience, and of course it improved as time went on because this idea of using art in connection with a building was becoming more prevalent throughout Australia. As it went on, the funds set aside for the work increased – it was now considered the right thing to do – so I was onto a better thing as time passed.

Sculpture depends entirely on your material. I've found that one of the most straightforward materials is wood. It's so durable even when it's placed outside – if you work big enough, wood's going to endure for a few hundred years if it's looked after. I've done some in the last ten years on a significant scale, and the beauty is that the funds go into labour. All I need is a chainsaw, axes and a healthy helper, with some machinery occasionally – bulldozers to move the heavy stuff. So you have practical problems, but wood is more straightforward. With other modern materials – concrete, metal and so on – you have to go to industry because you can't cope with it and you

haven't got the specialised knowledge that's required. But working in wood you're using simple cutting tools.

On the whole I enjoyed the sculpture commissions, and I think the relationship between artist and architect has improved considerably. But it has a long way to go because I don't think it's got to the point where the architect is willing to work with the artist at an early stage and perhaps bend his building a little bit, or change the material a little bit, to provide an area that will suit the work that's going to come in. If this is done you can obtain a nice overall relationship that creates a big atmosphere rather than an ornamental sort of a thing in a space that the architect didn't know what to do with. I think it's lack of practice, that's all. I'd like to see both architect and artist work together more, take more risks and get better at the job. It's a particular way of thinking – it's not sculpture, it's not architecture, but it's creating an atmosphere by bringing the two together.

These commissions are quite laborious things, and can take a year of work. With a lot of the big jobs I found myself in desperate need of some escape or relief, and I would turn to instant, immediate painting. That took me outdoors – painting on the spot, making drawings, coming back and painting from the drawings in a more figurative way. It was very satisfying. I thoroughly enjoyed that balance, if you like, to working in a controlled drawing-board sort of way, because after you've worked out your design, and perhaps constructed your model, the rest is just making it.

Untitled [*Tree trunks*] 1960

Working outside while doing major commissions not only keeps you fit and healthy and sharpens your responses to what you see, feel and experience about the landscape, it also supplies material, if you like, for those bigger jobs. It's fairly apparent that I'm very involved with landscape; in fact my whole interest is in nature in all its aspects in landscape. My bigger sculptures are concerned with it, my smaller stuff as well – in fact all the work I do, painting and sculpture, abstract as well as figurative.

Columns 1995

One valuable gain in working directly from nature is that you acquire greater sensitivity about light and seeing generally. I believe that even if you work very abstractly,

in a minimal sort of a way, you're still drawing on your experience of life – the physical business of seeing and the more subjective one of feeling. In other words you acquire skill; you improve your perception by cultivating this looking thing. The danger is often that you produce works from previous work. Although that's allowable to a certain degree, I don't think you can go on and on that way. You've got to refresh yourself now and again. My concern with light is in my drawings, it's in my paintings, it's in my sculpture, because they are simple forms depending on just the play of light. In fact at the moment I'm trying to paint light.

Some of my early 'light' works relied on optical illusion to give you a feeling of concavity, convexity and depth. Later on I got into some bigger ones where I attempted to get large enough and deep enough to envelop the viewer in a more physical, tangible sense. Although they rely on the light enormously, they don't depend on it quite so much because of that size, and I think that's one way of beating the problem of light – to go so big that one is swamped by the piece rather than viewing it as an object.

Overall I find that I'm using any means available to me to express my relationship with nature. I don't separate out painting from sculpture: I combine the two. I don't separate out non-figurative work from figurative work: I can work in both modes as necessary. Because I'm involved with nature, light becomes perhaps my greatest concern. It can be rendered with colour or without colour, but it pervades the whole of the work. I am just using what I can to say intelligibly what I feel, and achieve some form of excellence – which is rather an old-fashioned word perhaps – achieve some sort of excellence in doing it.

HOWARD TAYLOR 1986

opposite

Light source reverse 1994
oil on panel and synthetic polymer
paint on composition board
209 x 1209 x 9 cm
Art Gallery of Western Australia
Purchased with funds from the
Sir Claude Hotchin Art Foundation
1995

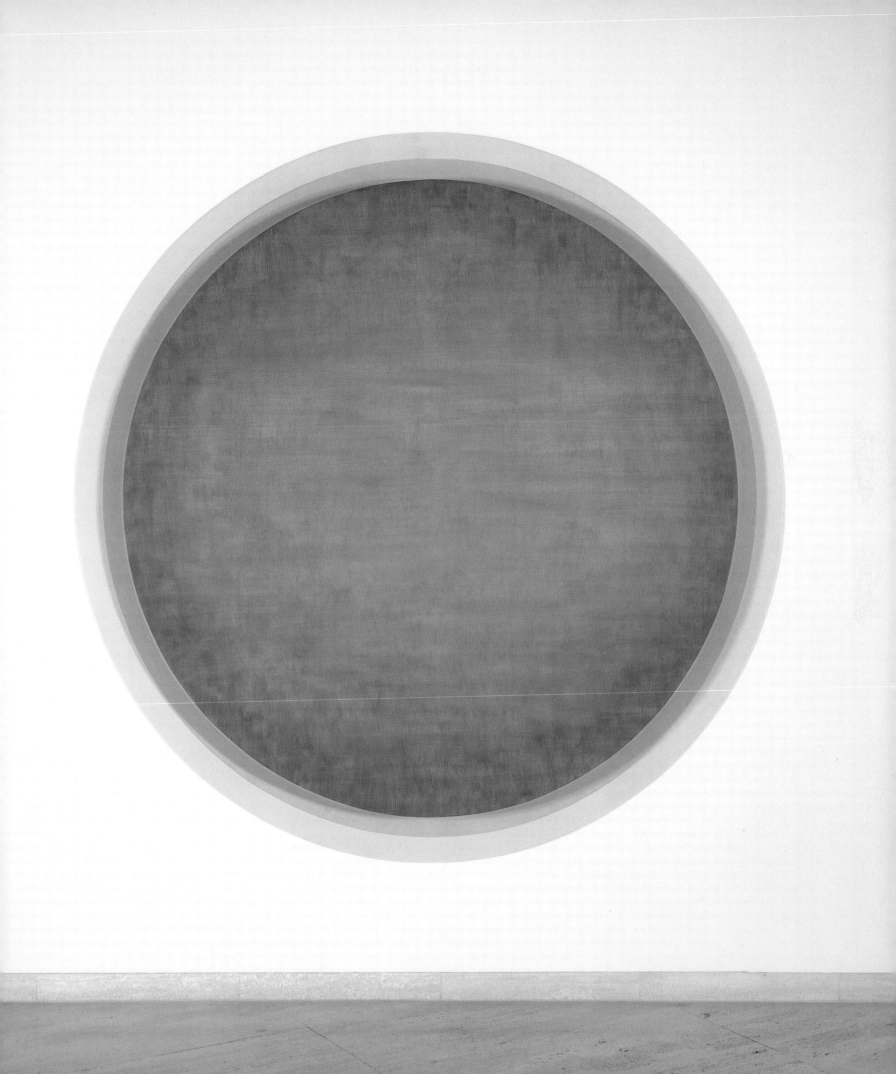

Light Source: Reverse

'The object in space' could very well be an alternative title for *Light source reverse* 1994. Some years back my work was concerned with questions of this kind – figure/ground – and although much of the work was of the conventional rectangle within a rectangular format, the figure drifted towards the circular, a disc or a sphere. This perhaps went back to an earlier realisation that the object seen in space was a fundamental aspect of vision, and if it could be understood visually and painted convincingly on the flat surface of the canvas, one was getting to grips with the painter's vision.

Recently I noticed that Nicolas Poussin had said that there were two types of vision: the 'aspect' – the simple and natural kind; it could be qualified by reflective vision – and the 'prospect' – attentive observation of objects which looks for the means of understanding vision and perceiving objects.[1] Poussin expected this kind of rational vision from his patrons and spectators.

As a painter and sculptor involved with landscape and the observable natural world, this was most heartening, to find the opinion so well expressed so long ago. Today Poussin would need to qualify and enlarge the prospect, but it would be easy for a painter of such involved and complex work. Later on Paul Klee took care of the intangibles and the subconscious with the simplest of his diagrams, where the relationship of artist to object was shown with a direct line from eye to object, with upper and lower curved lines to care for the subjective and objective connections. Both artists start with the eye and, doubtless, both would say the painting itself becomes an object, and this relationship of perception follows right through the process of making the painting. It is expected that the 'spectator' has similar faculties in seeing the finished painting as an object.

The painter does make something – it involves materials and techniques. The more knowledge about the properties of colour, of paint, of pictorial elements and design the greater will be his resources in enlarging 'the means of understanding vision and perceiving objects'. This has always interested me; it is tangible enough to study and relevant today in the most diverse directions, from the figurative to non-figurative.

It can be not only constructive but stimulating. A restricted palette can aid this if the dimensions of colour are extended by knowledge of paint qualities.

In landscape the spherical figure is present in both sun and moon and, if divested of associational values, they become an excellent subject for study: 'the object in space' – this endless variety, conditions of light, scale, movement, atmosphere. With *Light source reverse*, the figure is isolated from a ground but is intended to be seen on a light neutral wall and illuminated frontally with suffused light. The figure is given slight relief and large scale to stand up to any vagaries of exhibition. The two bands of matt colour (from the 'non-light' side of the spectrum) at the contour of the central disc soften the transition from it to the wall. In fact, there is a blurred 'humming' contour. The accent on this dominates the minor action of slight modelling in the disc itself – a flattened sphere. After a series of suns and moons as light sources, the use of coin terminology, observe-reverse, was suggested by the dark nature or side of the disc being turned towards the spectator, the light source of the face showing as a glimmer only at the contour. Finally, the after-image of the dark figure on the wall is a helpful member of the team in the overall scheme of relationships and reversals. Shifting the eyes to the side wall gives a light figure.

HOWARD TAYLOR 1997

Plates

Study for *Portrait of a blackboy* 1950

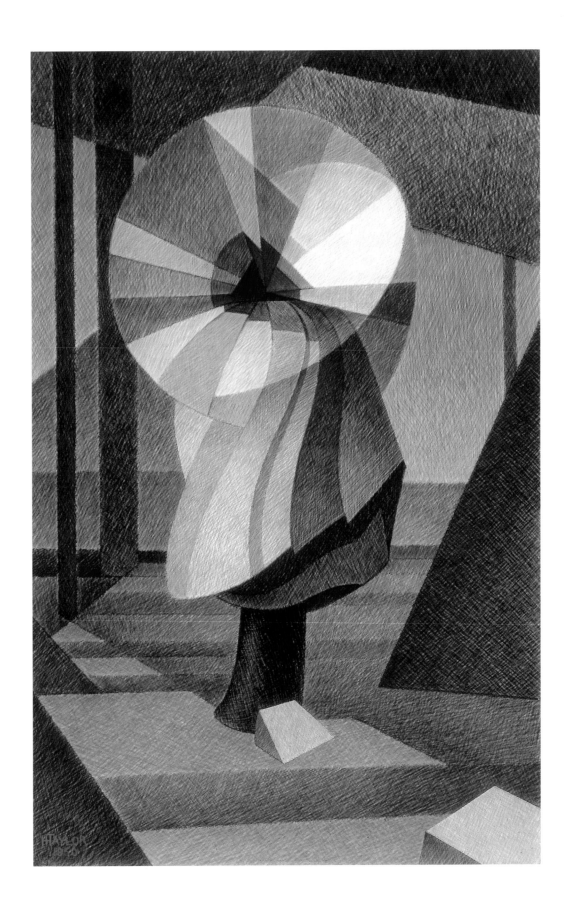

Portrait of a blackboy 1950

Maquette for *The black stump* 1974

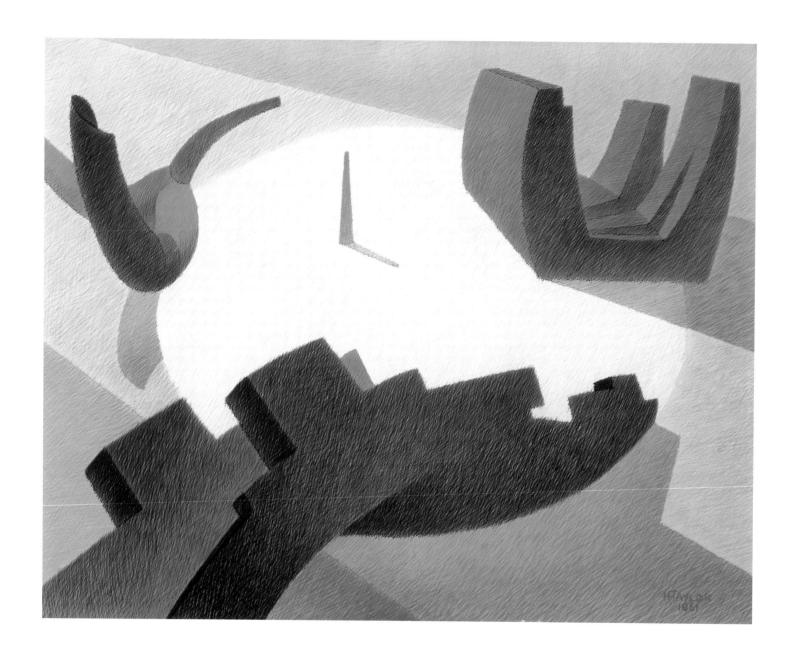

Stumps and ash 1951

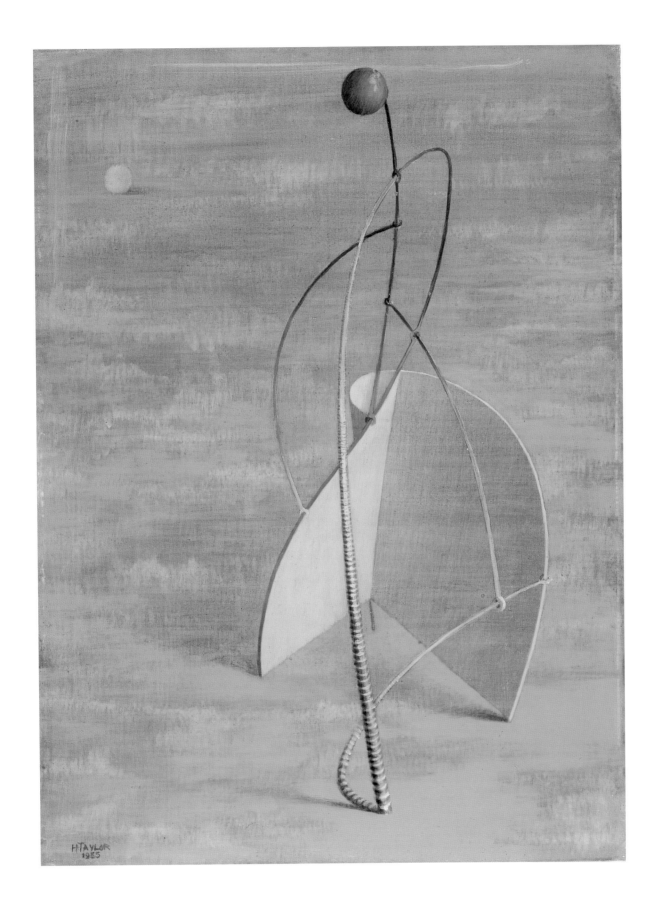

Creature 1955

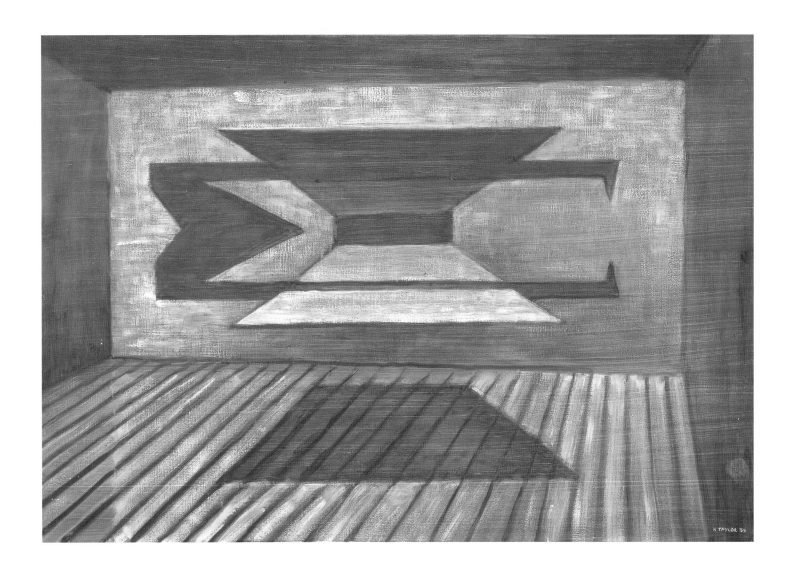

Untitled [*Structure–chiaroscuro*] 1955

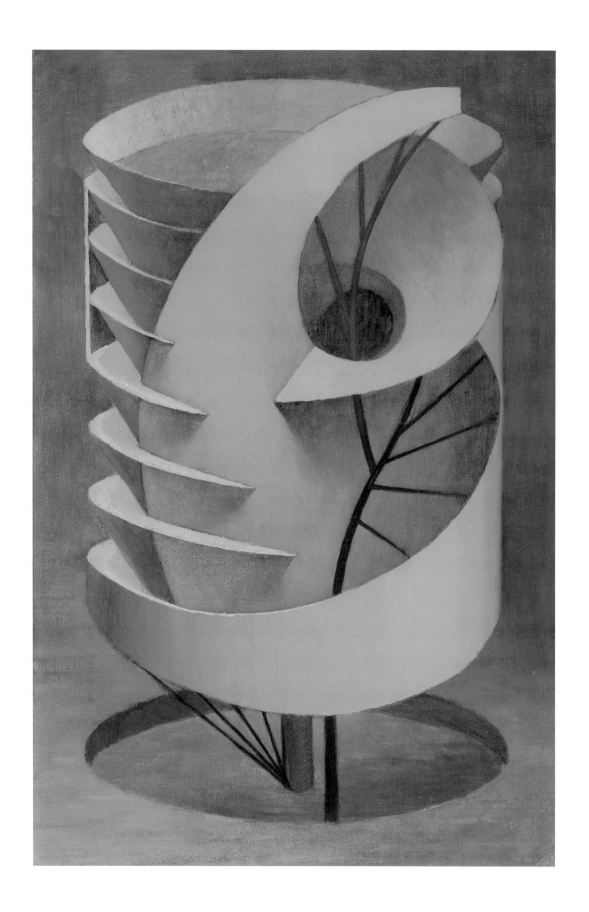

Tree cylinder 1956

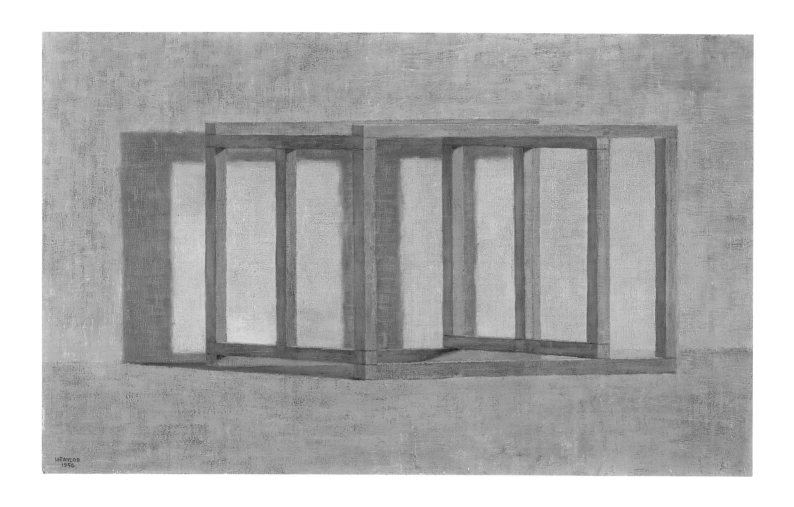

Wood structure 1956

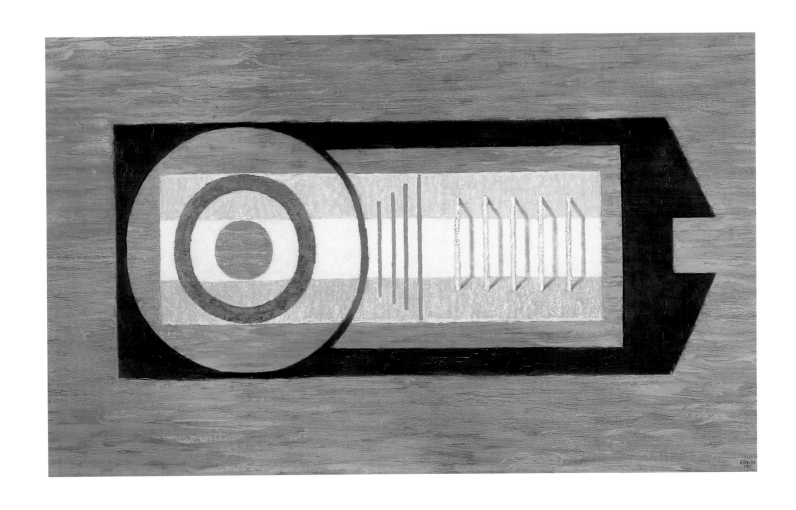

Bush structure – flight 1956

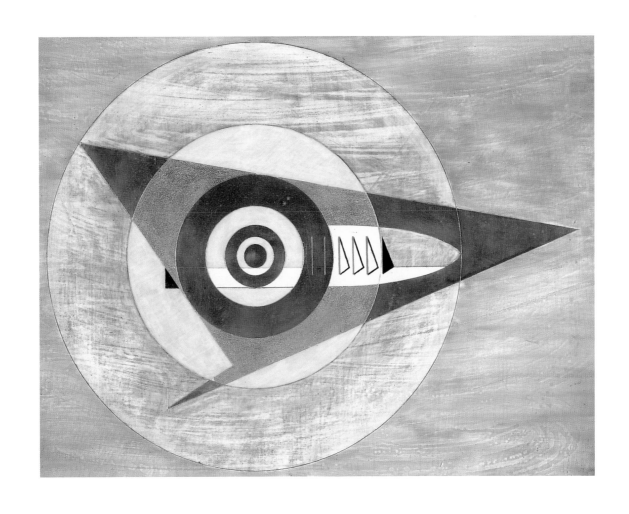

Flight 1956

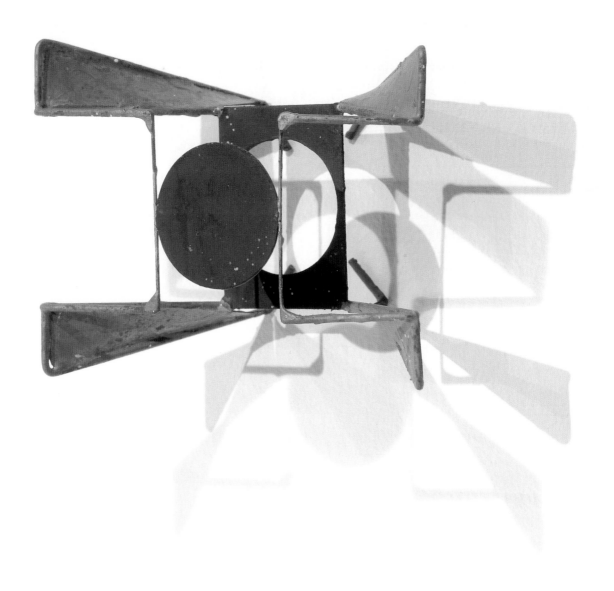

Untitled [*Object in space*] 1956

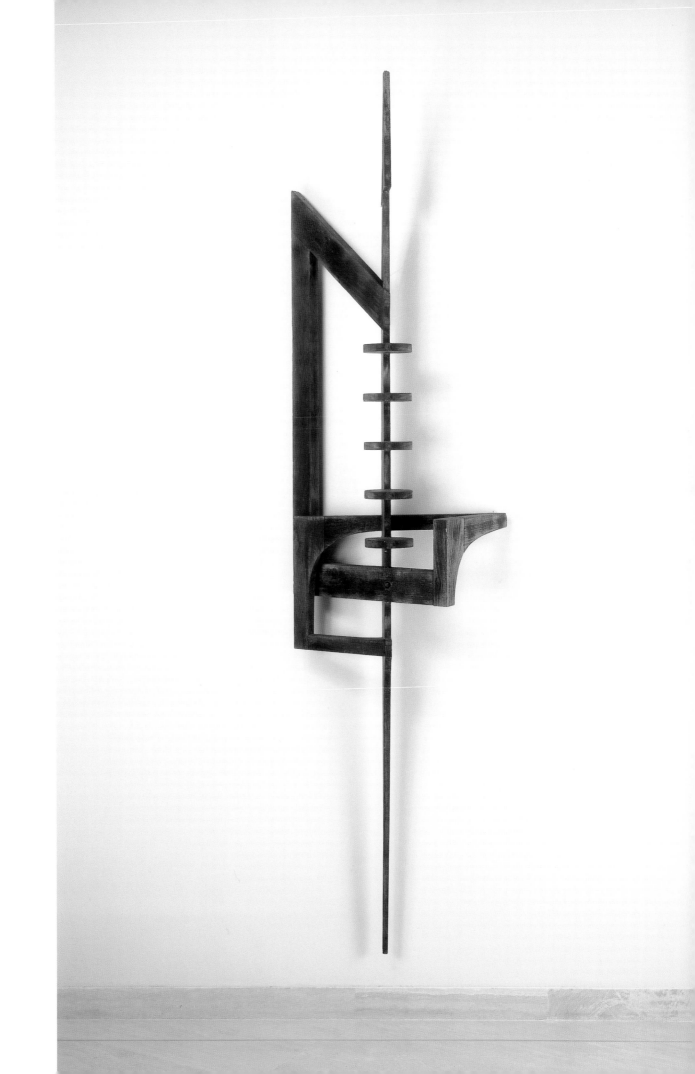

Stick insect 1958

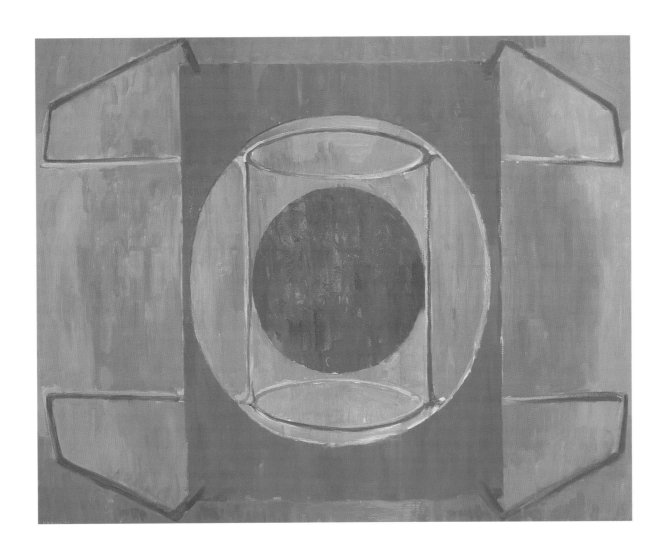

Untitled [*Object in space*] 1958

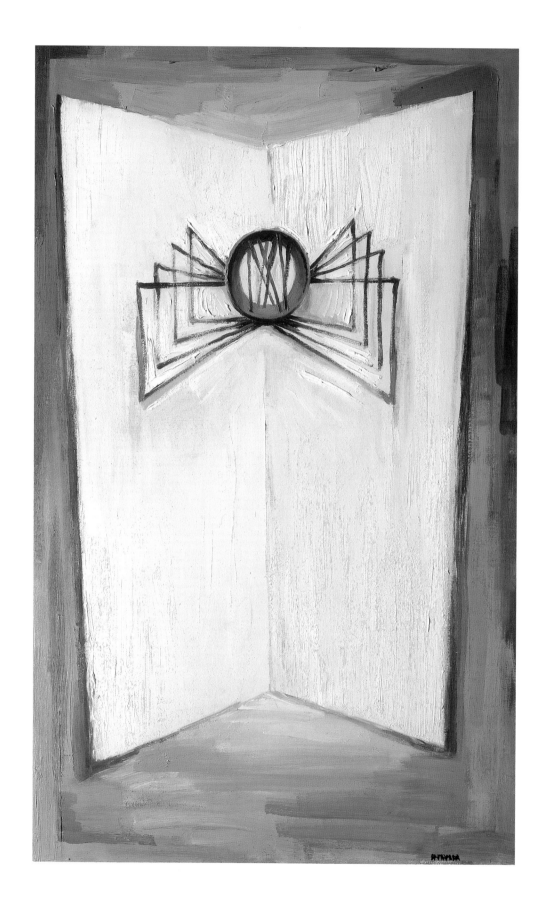

In the corner 1958

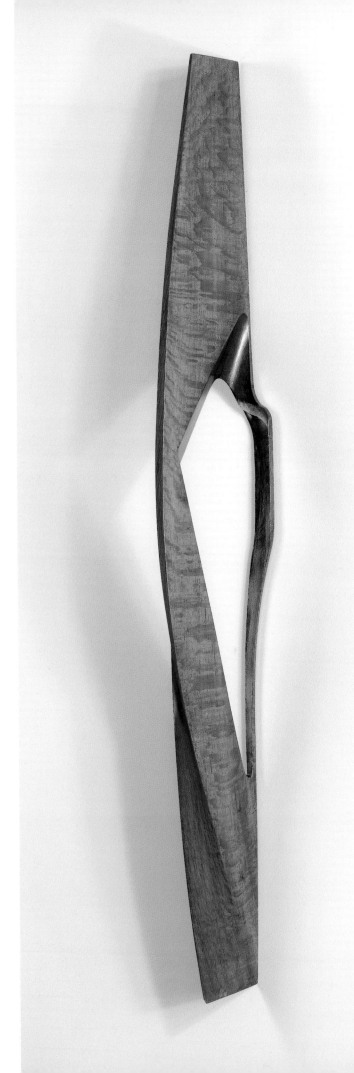

Untitled [*Flying object*] c1960–63

Bush form 1963

Karri forest 1963

Untitled [*Trees to sky*] 1963

Column 1970

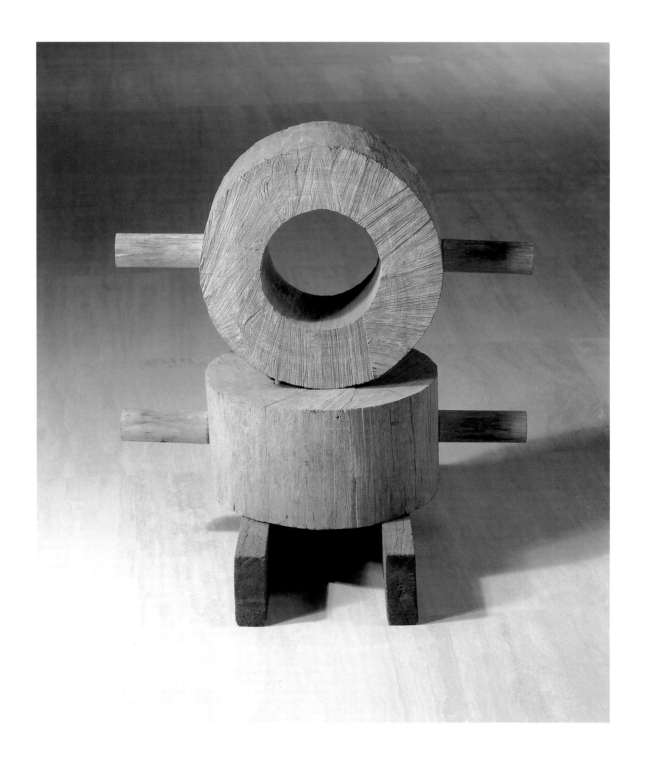

Turn about 1970

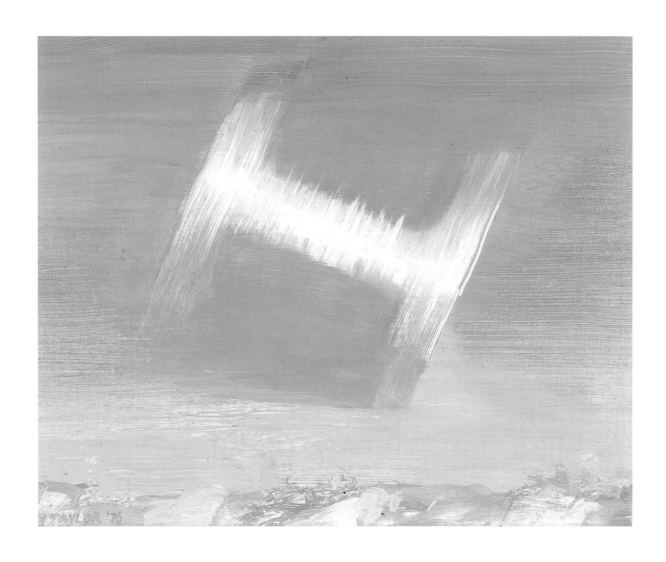

Rainbow trace 1976

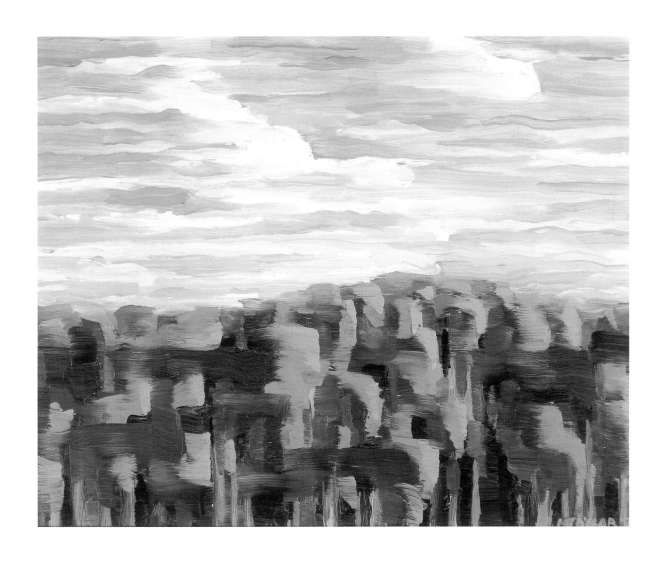

Trees and sky 1976

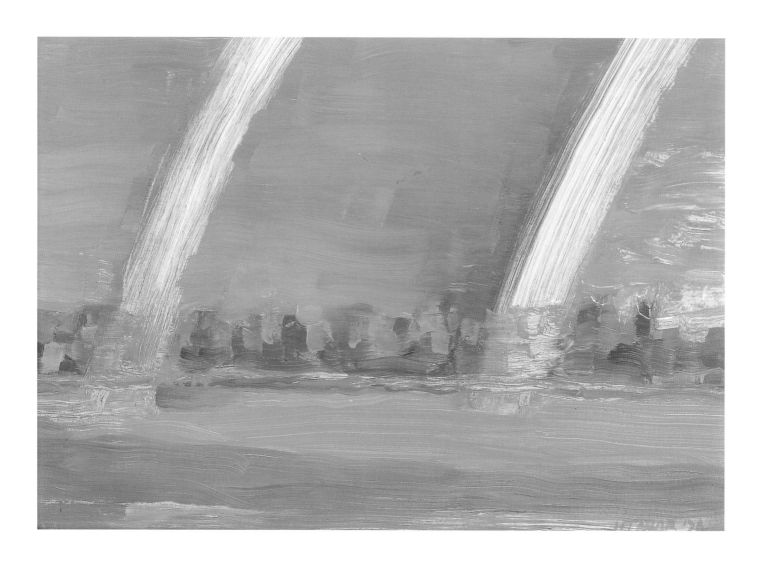

Rainbow and supernumerary 1976

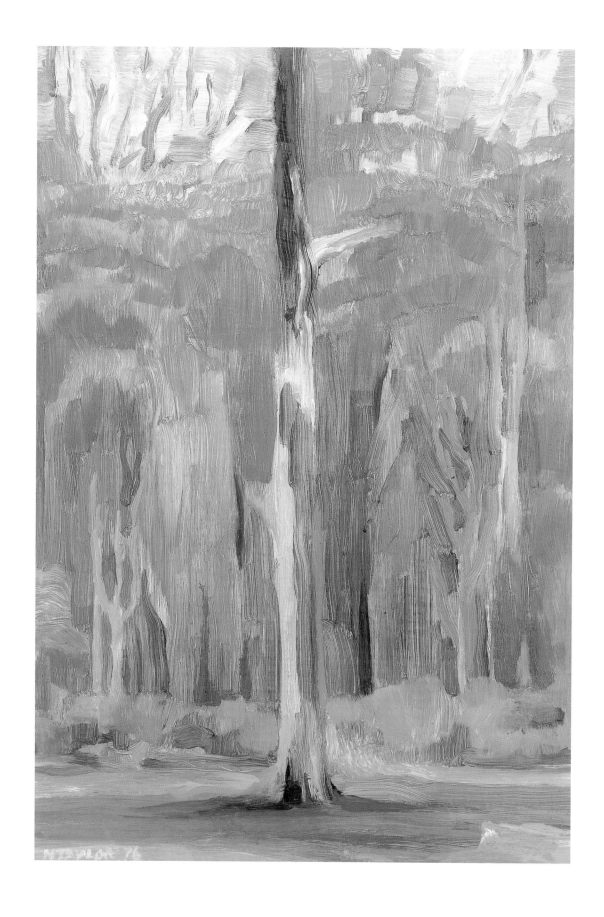

Through the window 1976

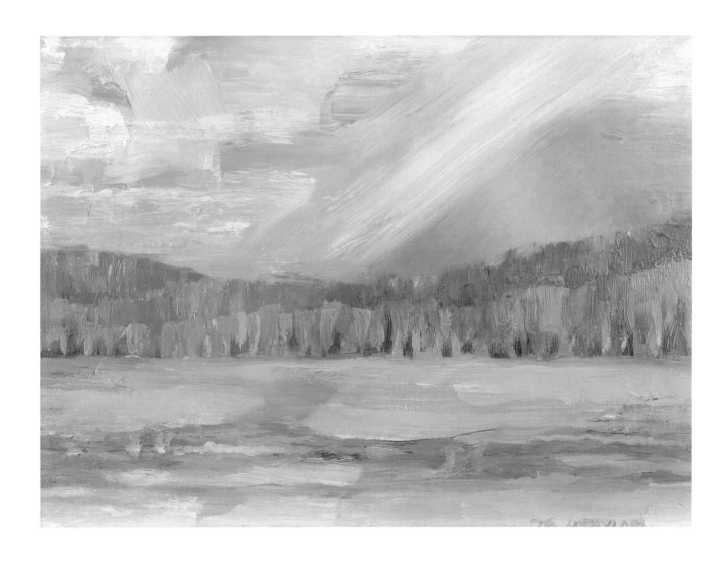

Distant rainbow 1976

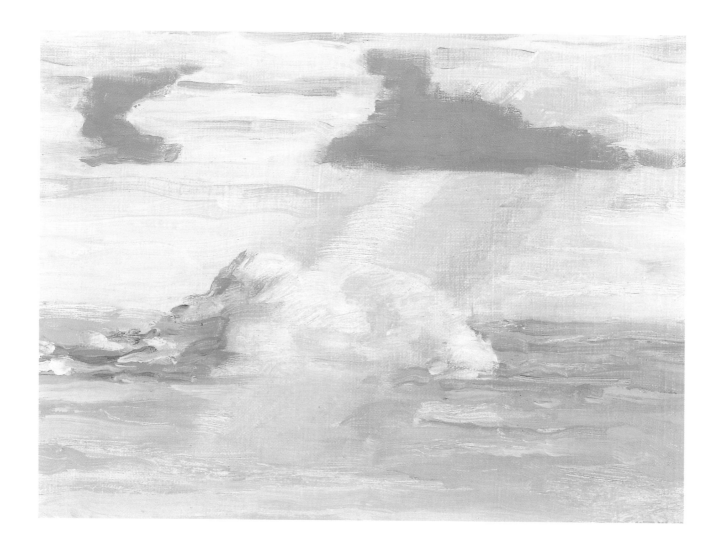

Rainbow veil 1976

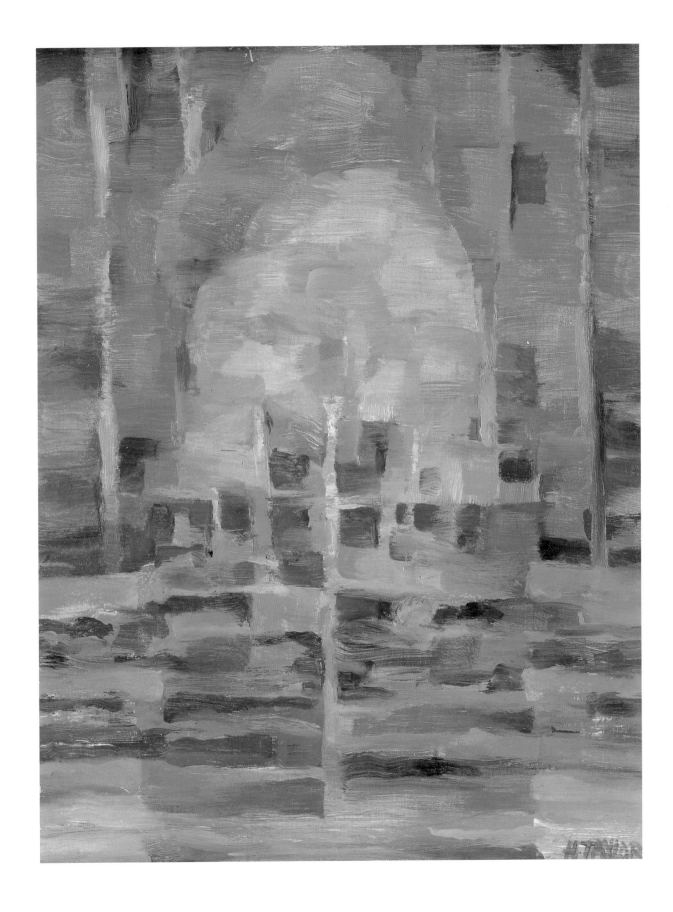

Sapling 1976

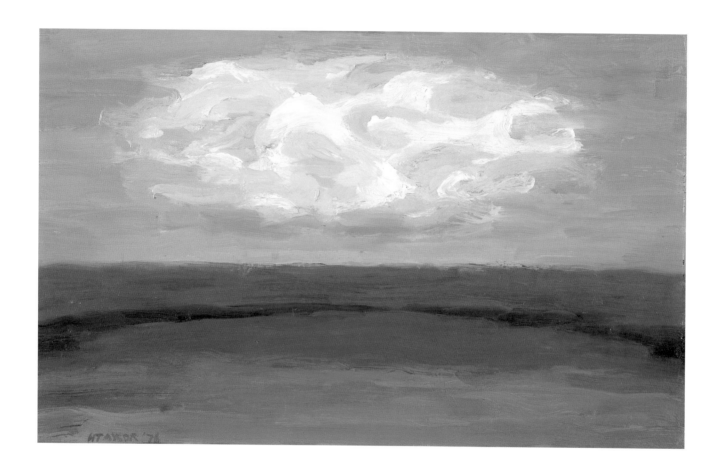

Northcliffe across the paddock 1976

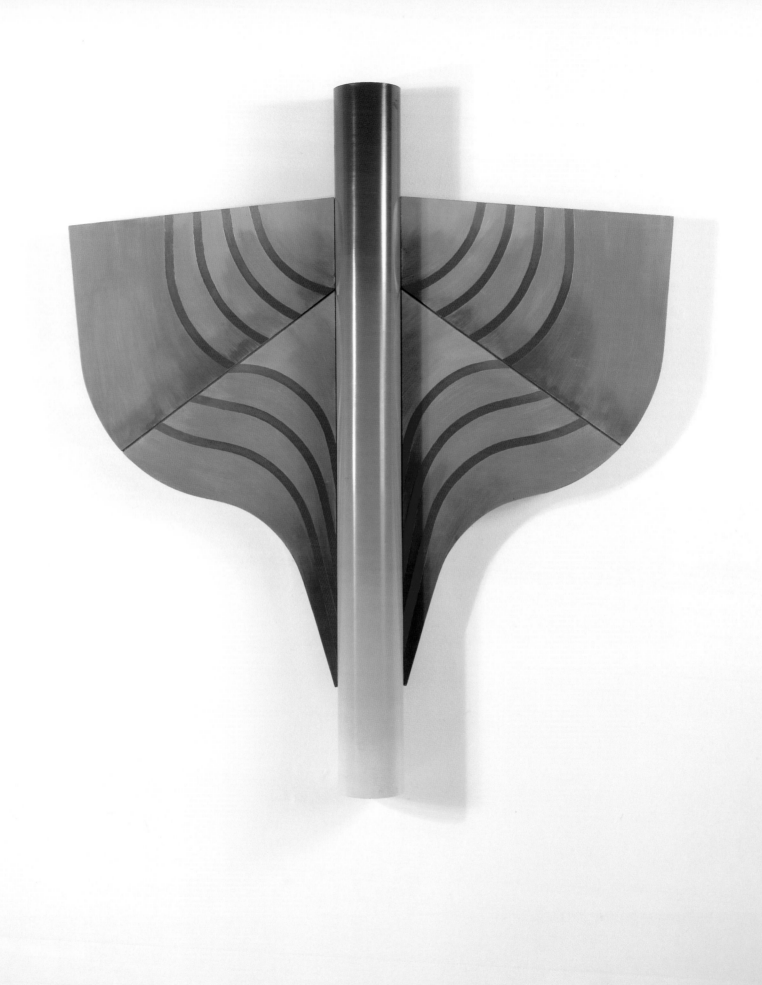

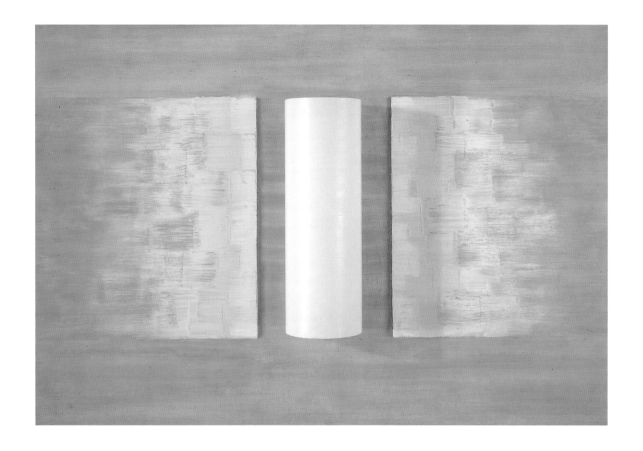

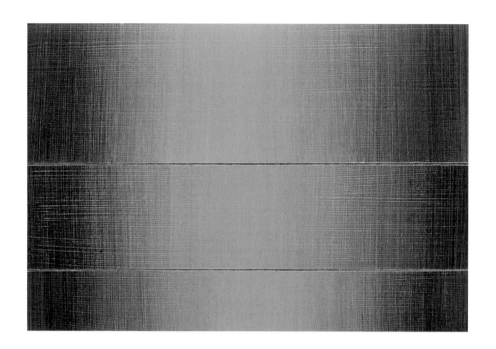

Tree form 1980

Study for *Forest land* 1982
Charred forest fragment c1983

Forest land 1982

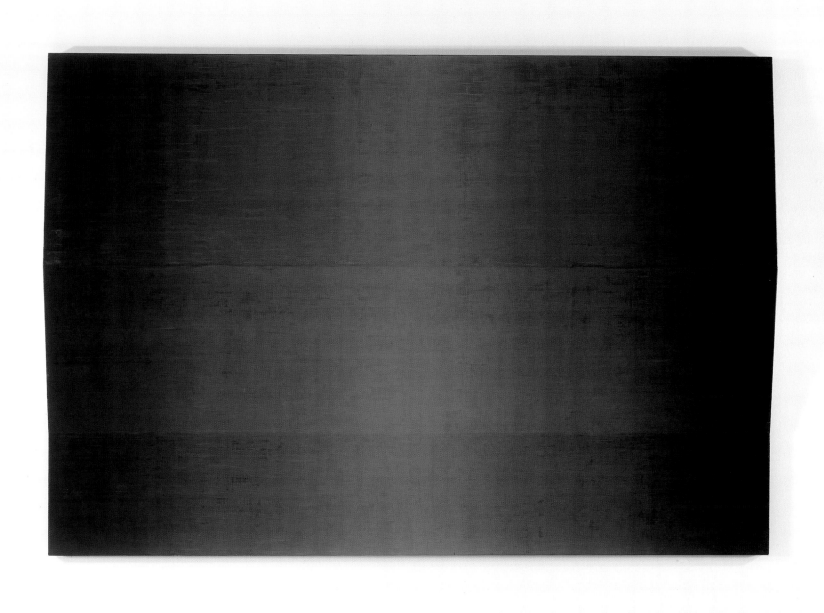

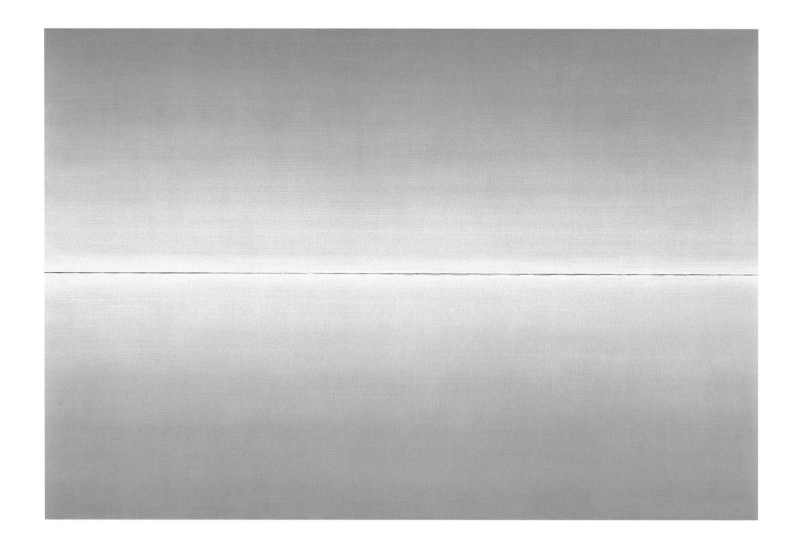

Open country I 1982

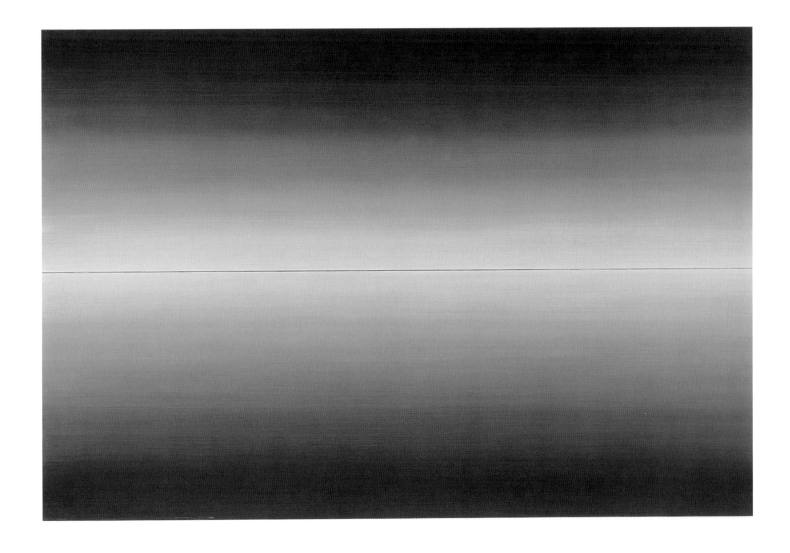

Open country II 1982

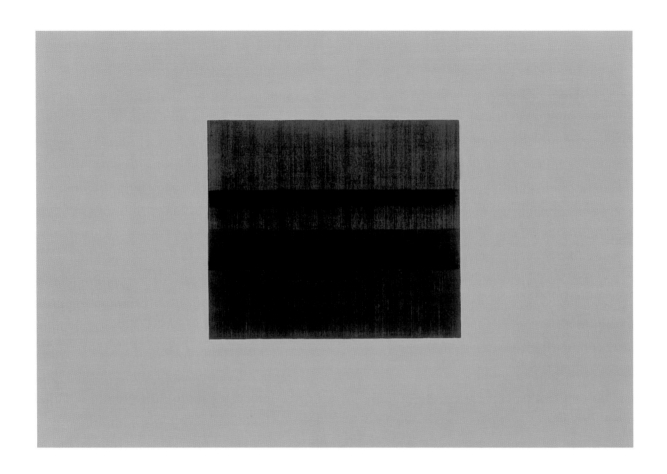

Masked landscape 1984

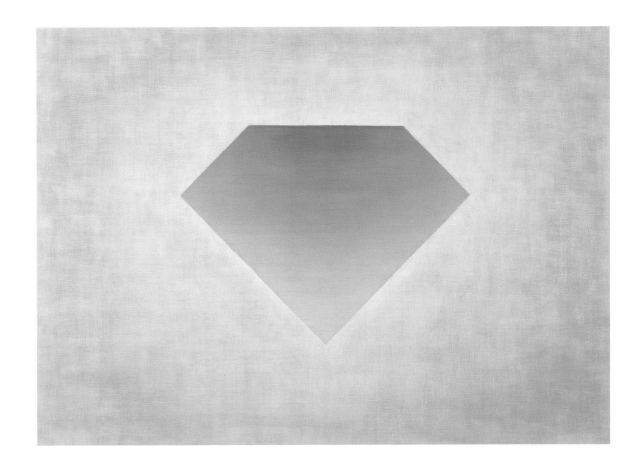

Landscape emblem 1984

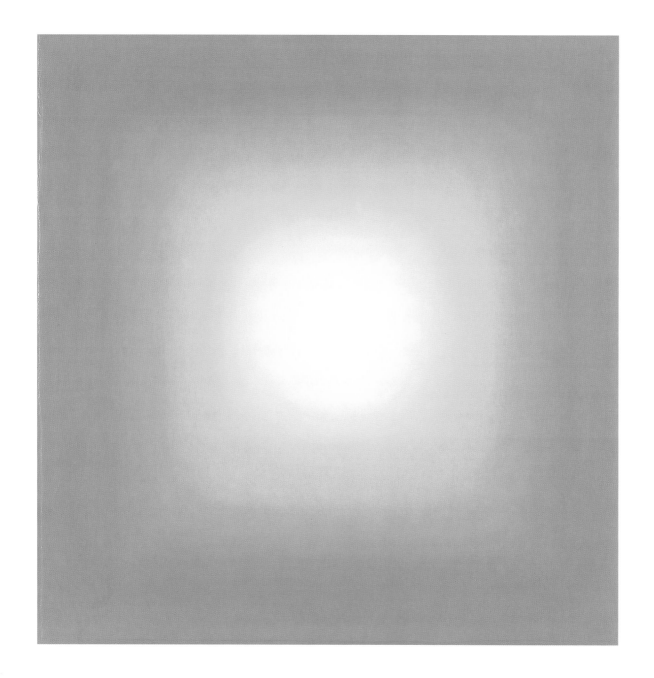

Green paddock illuminated 1986

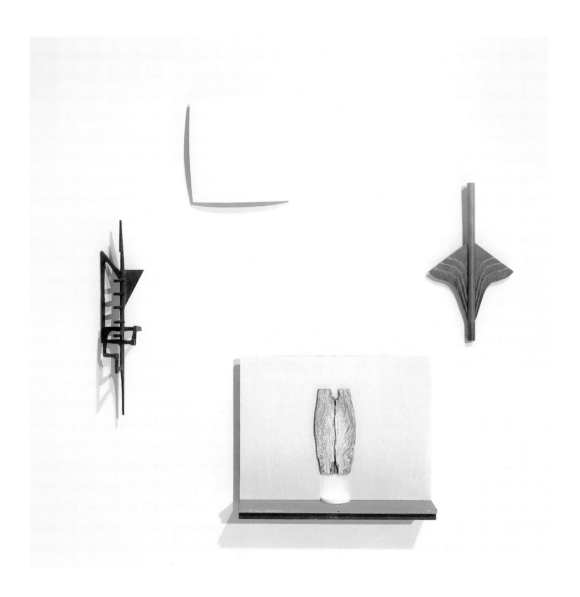

Stick insect 1957
Study for *Segment of a sphere* 1987
Study for *Weathered jarrah* 1996
Plant figure 1977 *Segment of a sphere* 1988

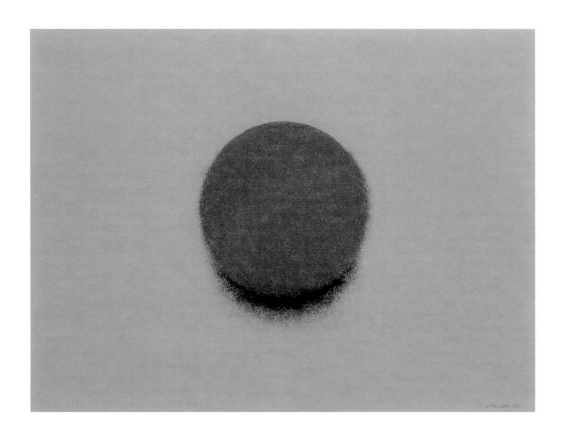

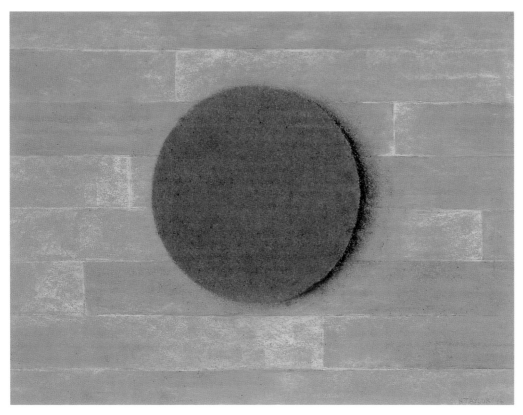

On the ground 1989
On the wall 1994

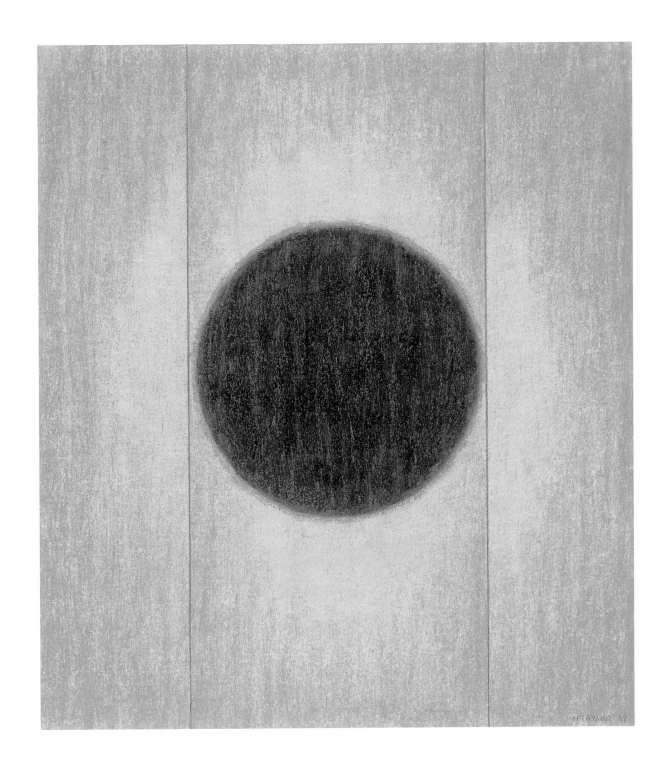

Study for triptych 1989

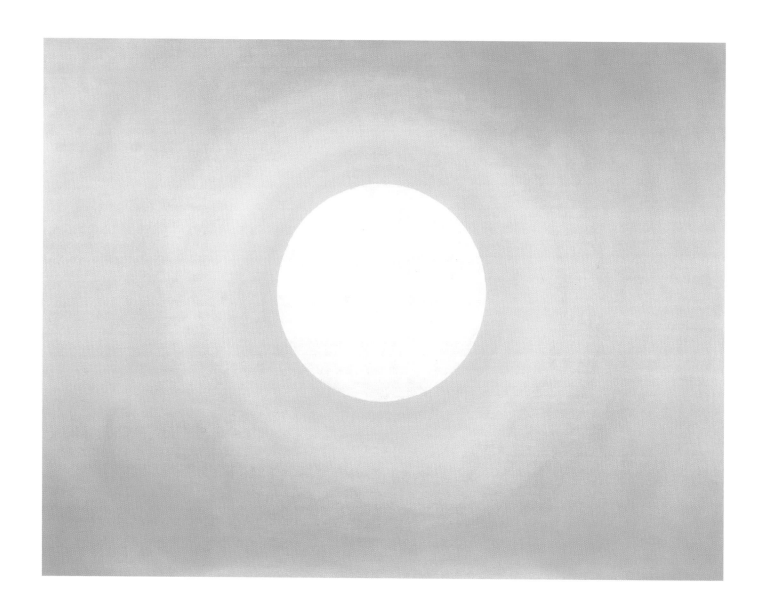

Sun figure 1989

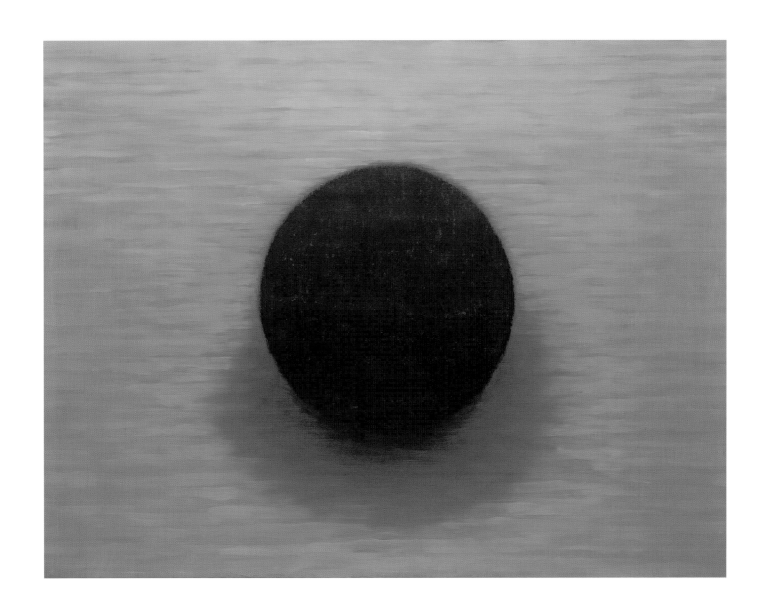

Object on the ground 1989

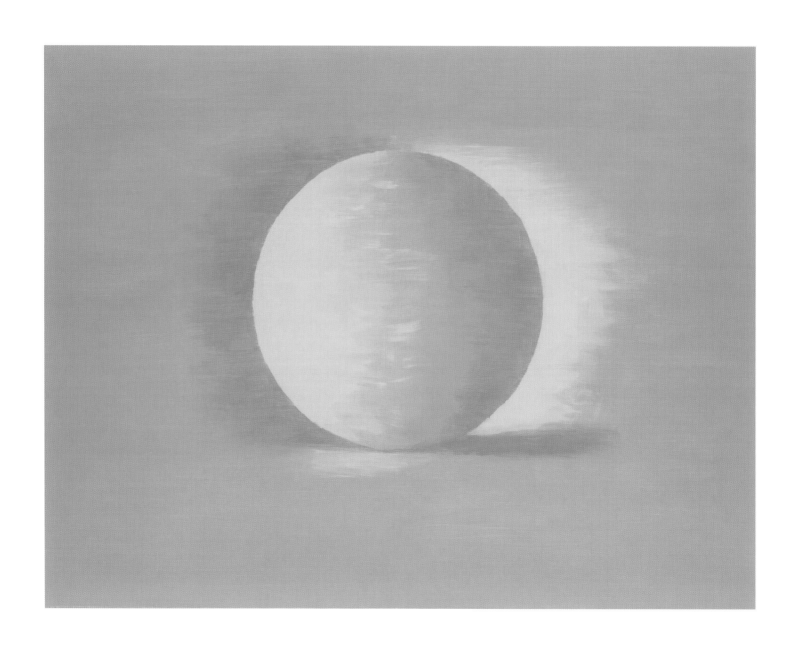

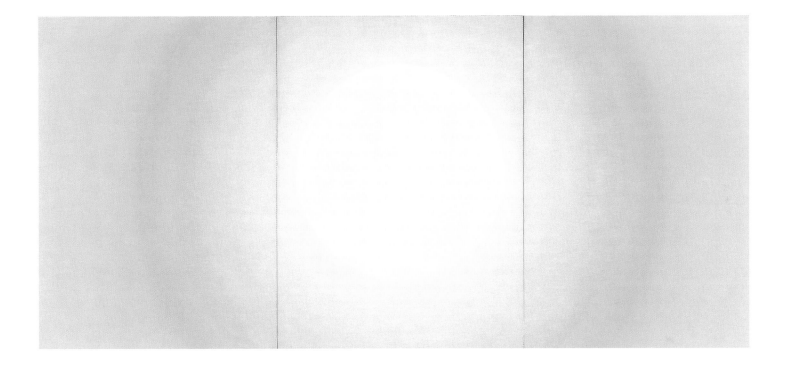

Light figure 1992

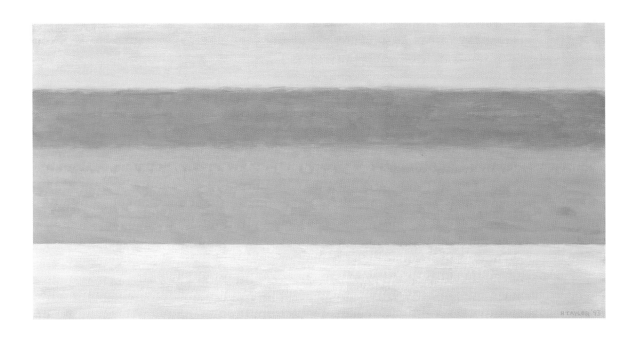

Tree line with blue cloud 1993
Tree line with cloud shadow 1993

Tree line 1993

Still life with black figure 1994

Contracurve 1994

Heavy object 1994 *No horizon* 1994

Internal cylinder 1994 *Four part unit* 1994 *Foliage panels* 1994

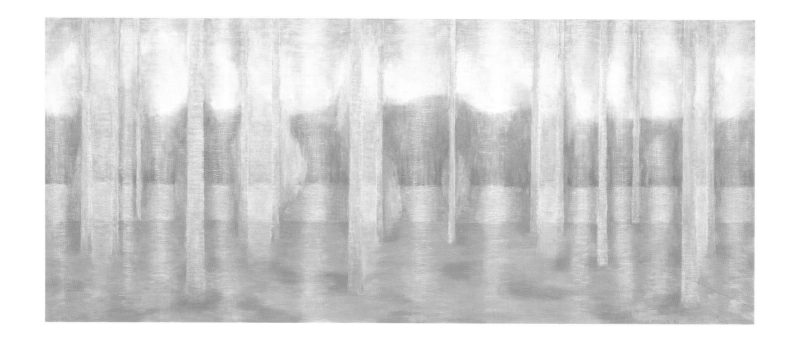

Farm landscape 1996

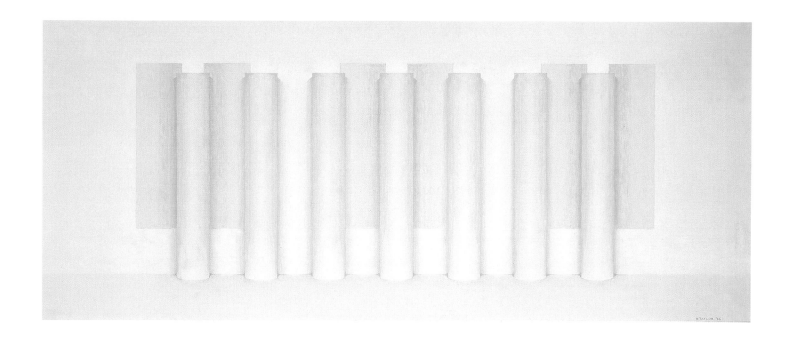

Colonnade study 1995

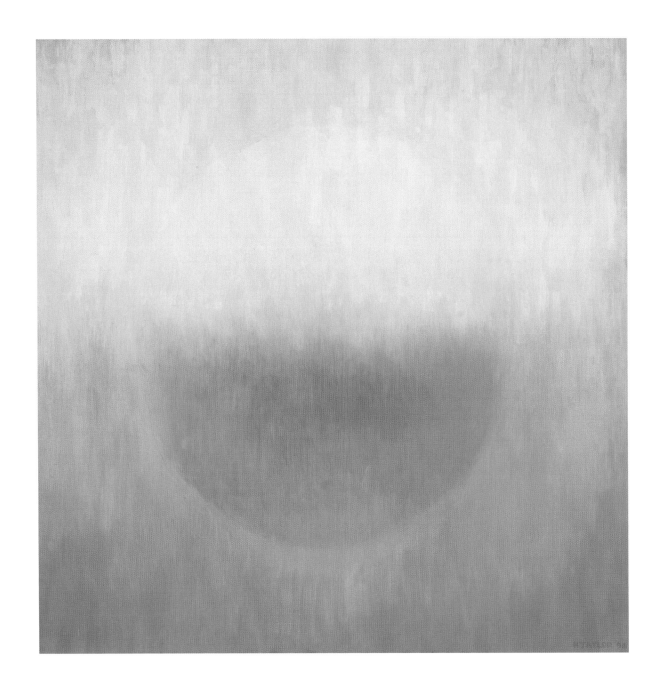

Sphere 1996

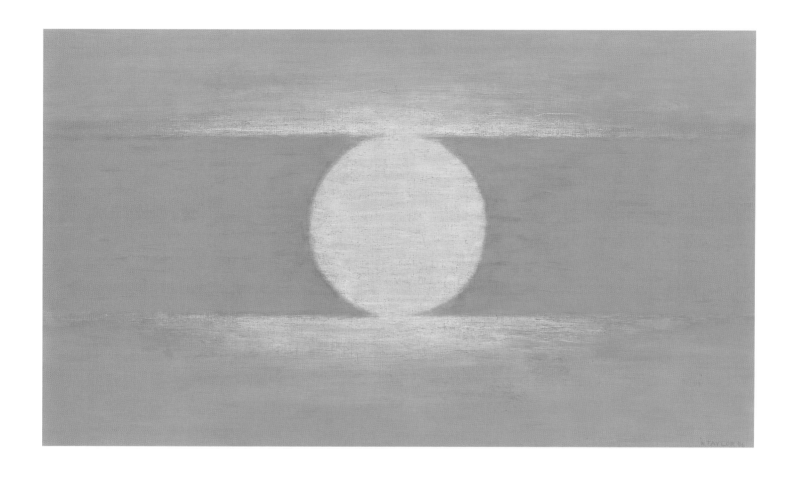

Bush fire day 1996

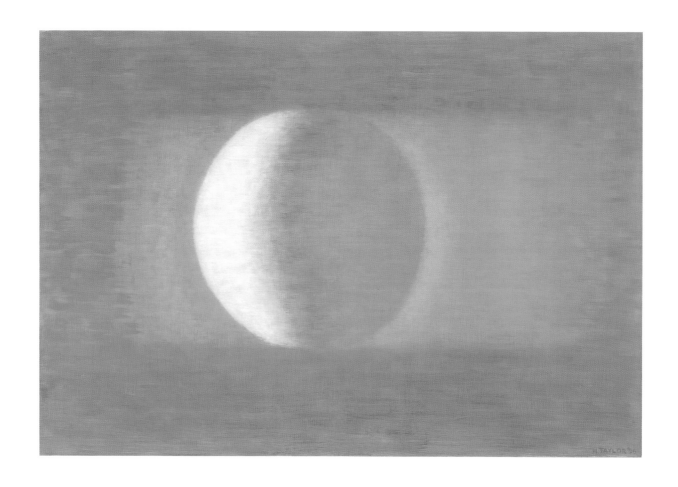

Moon passing 1996

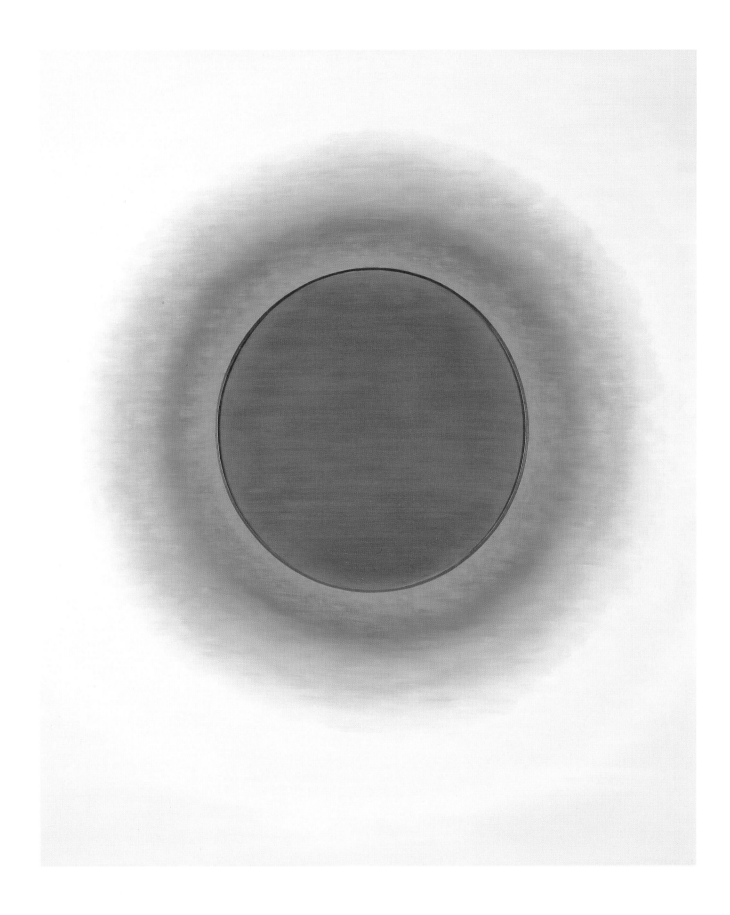

Sun wall 1997

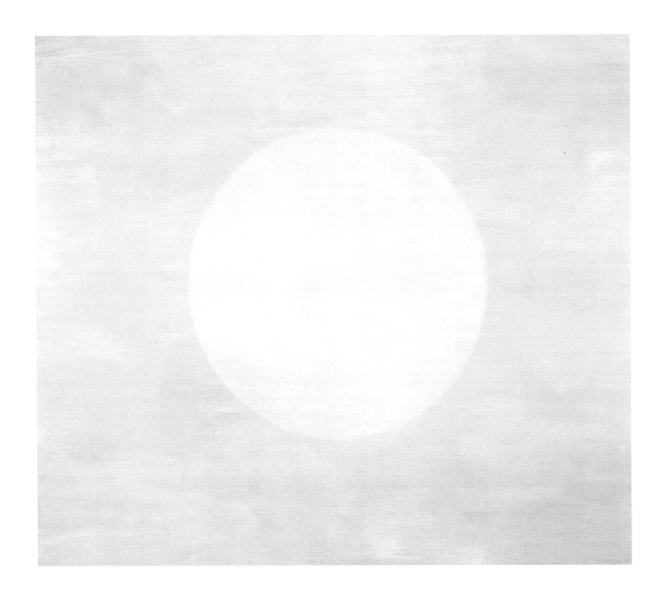

Day time moon 1997 *Weathered jarrah* 1997

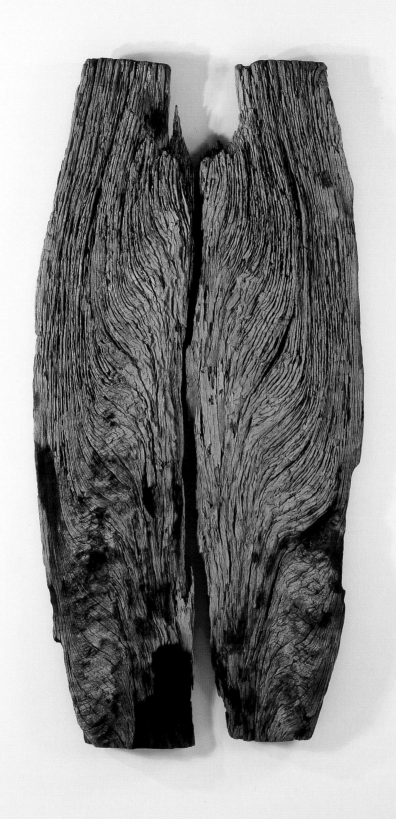

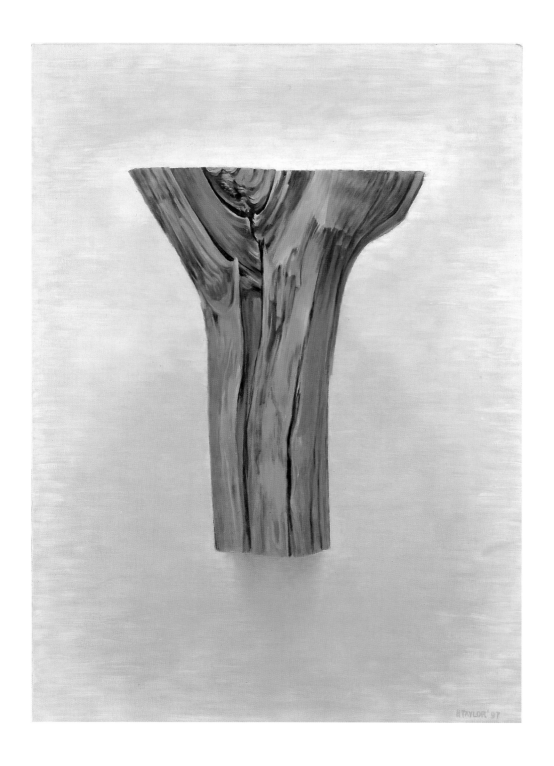

Tree fork fragment 1997

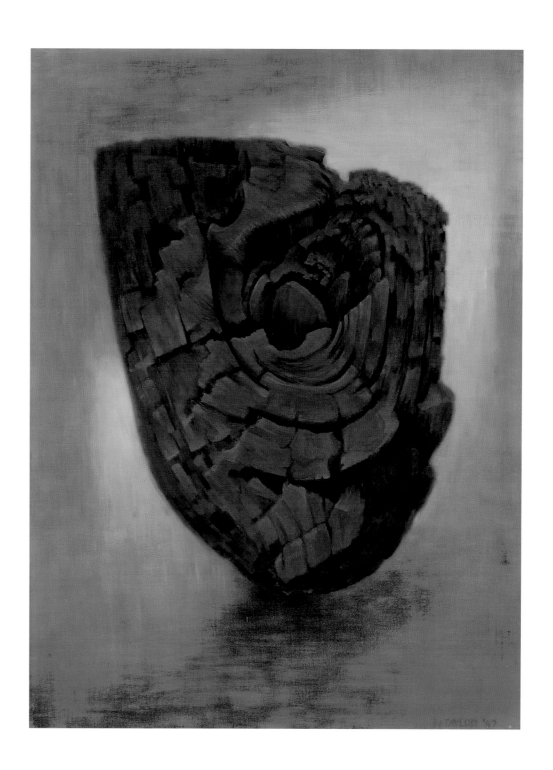

Charred forest fragment 1997

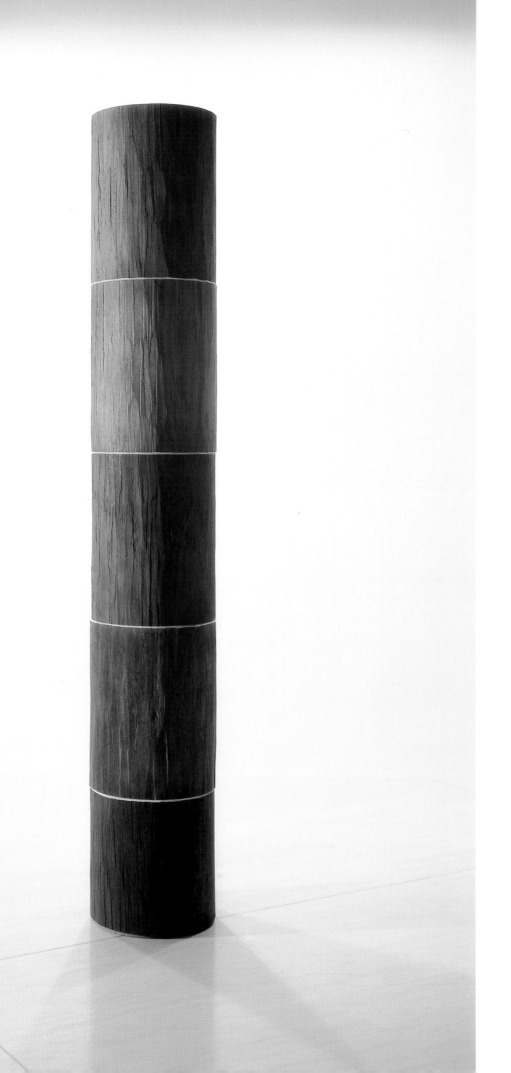

Column 1998

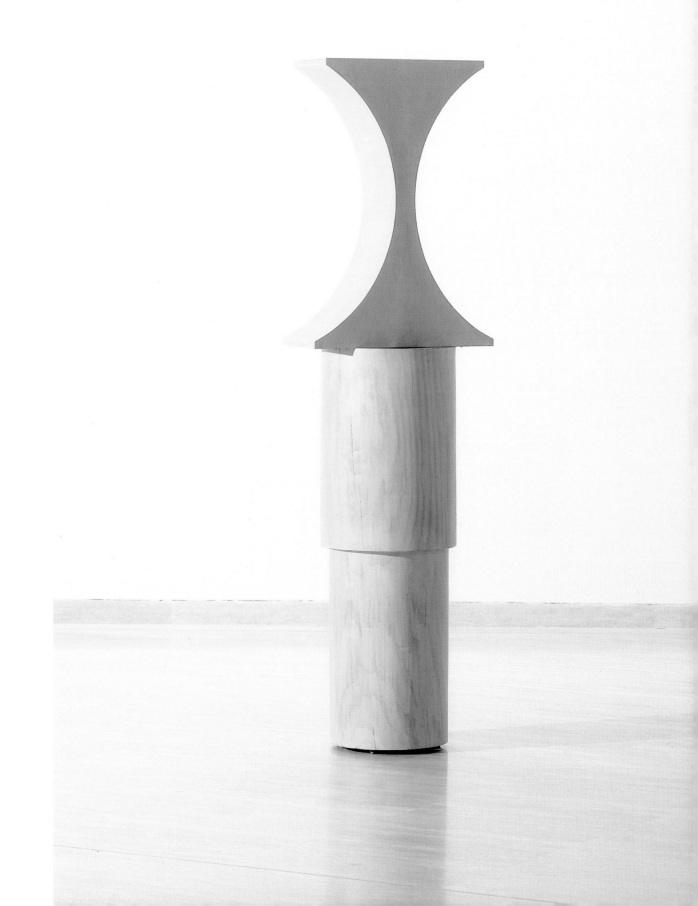

Forest post 1998

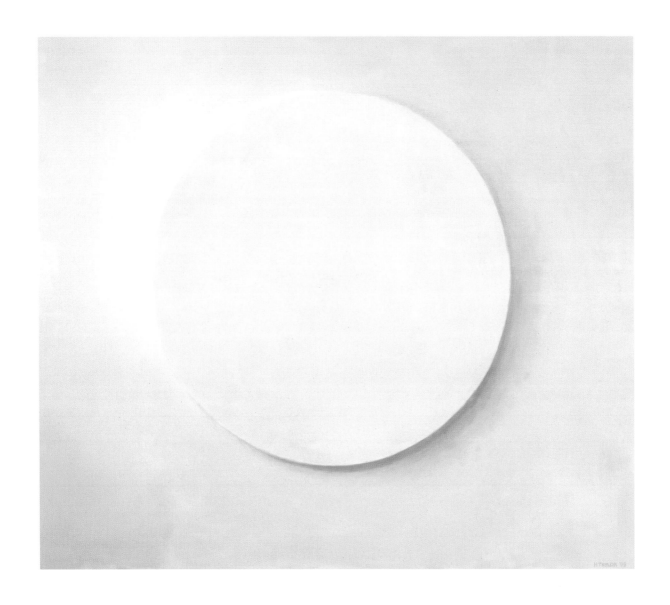

Studio wall 1999

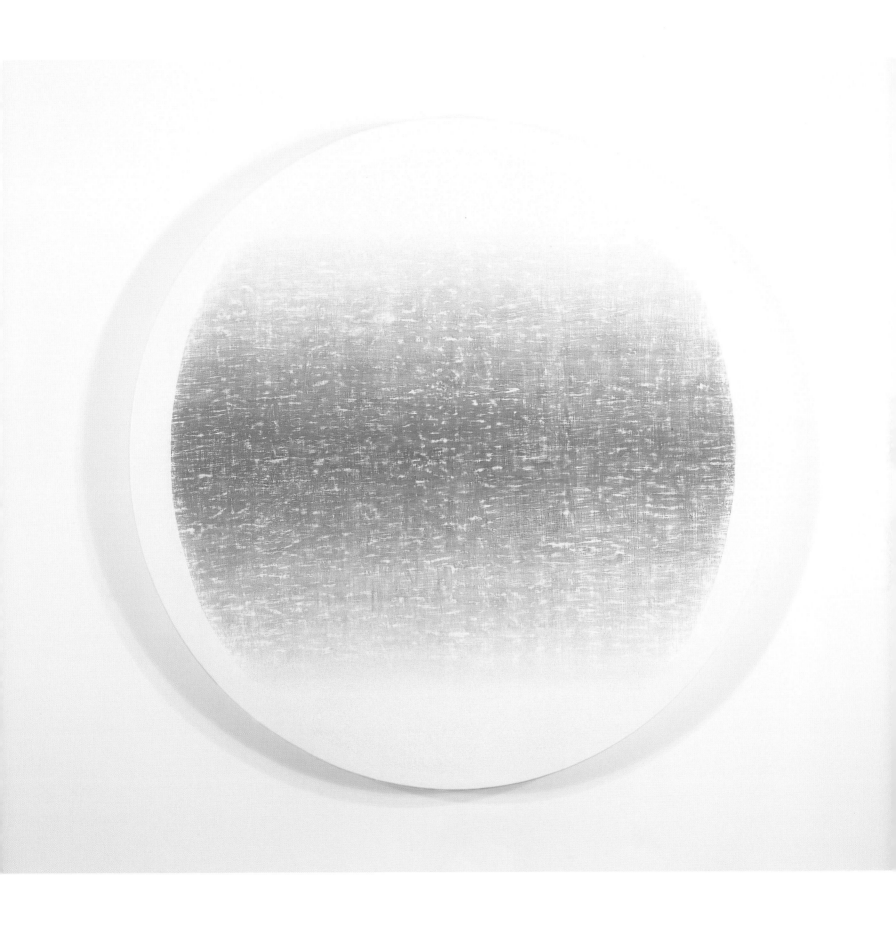

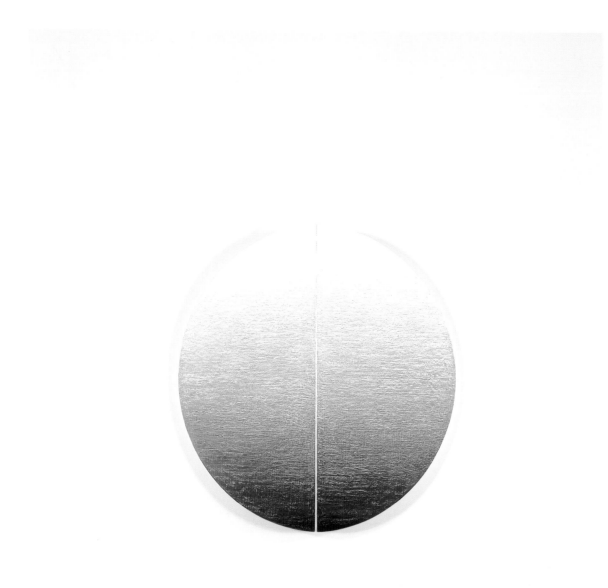

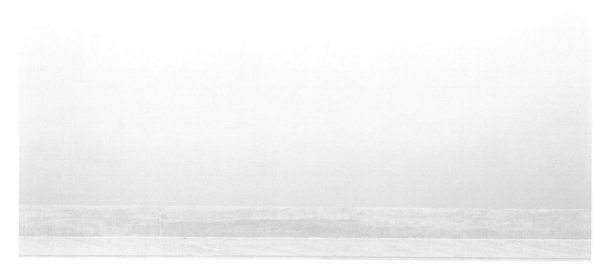

Divided sphere 2000

Discovery 2000

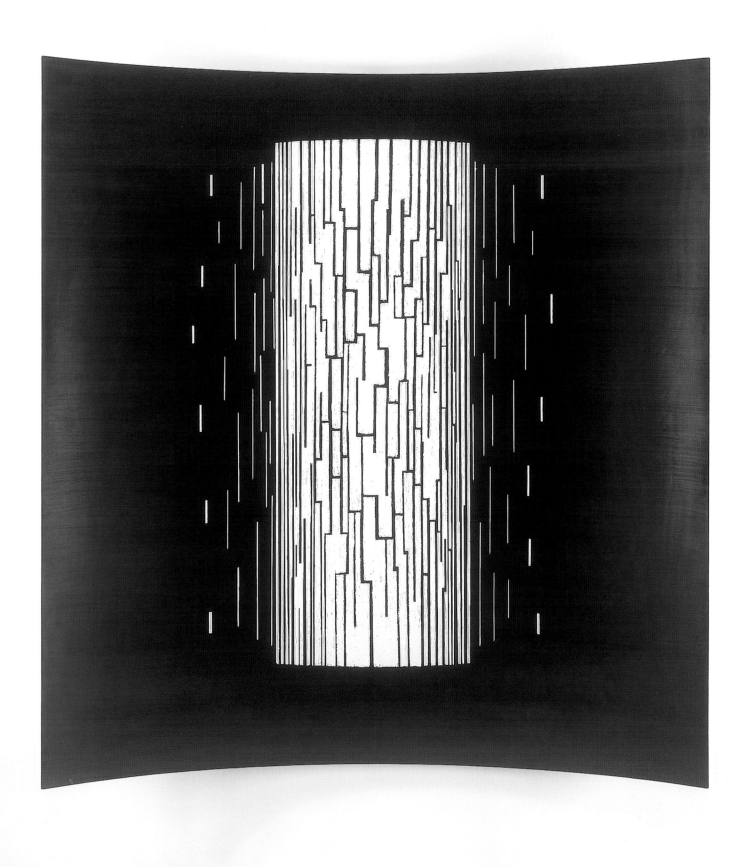

Howard Taylor, studio interior, Northcliffe 1996

Notes and Credits

THE INVENTIVE EYE *pages 13 to 31*

1 Howard Taylor, draft notes for 'Light Source: Reverse' 1997, black ink on paper with pencil schematic drawing of
 Light source reverse 1994, 29.7 × 20.8 cm, estate of Howard H Taylor. Six drafts, all in the artist's hand, in pencil and/or ink
 exist for 'Light Source: Reverse' 1997. Taylor also produced one typed manuscript with the same title in 1997.
 Sheet dimensions and medium description are indicated in the following notes to distinguish each draft.

2 Howard Taylor, pencil annotation on third study for *Wood Structure* 1956, pencil on newsprint, 16.6 × 20.2 cm,
 estate of Howard H Taylor.

3 Howard Taylor was interned as a World War II prisoner of war, from 19 May 1940 until the end of the war, in
 POW camps *Dulag Luft* Oberwesel, *Oflag IXA* Spangenberg, *Oflag VIB* Warburg and *Stalag Luft III* Sagan (Germany) and
 Stalag XXA Thorn and *Oflag XXIB* Schubin (Poland). For a discussion of Howard Taylor's POW camp drawings see
 Gary Dufour, 'Howard Taylor', in *Artists in action: from the collection of the Australia War Memorial*, Australian War Memorial,
 Canberra, 2003, pp. 74–75.

4 Howard Taylor, draft notes for 'Light Source: Reverse' 1997, pencil on paper, 35.8 × 27.2 cm, estate of Howard H Taylor.

5 Barnett Newman, 'The problem of subject matter' (1944–45), posthumously published in *Barnett Newman: selected
 writings and interviews*, ed. John O'Neill, Alfred A Knopf, New York, 1990, p. 80.

6 See: Herbert Molderings, 'Relativism and a historical sense: Duchamp in Munich (and Basel …)' in *Marcel Duchamp*,
 Hatje Cantz Verlag, Ostfildern-Ruit, 2002, pp. 16–19.

7 Howard Taylor, draft notes for 'Light Source: Reverse' 1997, pencil on paper, 15.6 × 21 cm irregular, estate of Howard H Taylor.

8 Howard Taylor, letter to author, 24 May 1998, Art Gallery of Western Australia.

9 Howard Taylor, draft for letter to bookseller, c1995, pencil on newsprint, 25.5 × 21 cm irregular, estate of Howard H Taylor.

10 See: Paul Hills, *Venetian colour marble, mosaic, painting and glass 1250–1550*, Yale University Press, New Haven, 1999,
 pp. 133–153, for a discussion of relational colour in Venetian art.

11 Howard Taylor, 'Light Source Reverse', posthumously published in *Art & Australia*, vol. 39, no. 3, March–May 2002, p. 389.

12 'Light Source Reverse', 2002.

13 Howard Taylor, annotation in sketchbook 68A, 1968, estate of Howard H Taylor.

14 Howard Taylor, description of the 'kit bag': 'Colour to me is just one of the tools in my kit bag …
 Opacity, transparency, thick and thin paint [are] relevant today. Materials and handling must go into the kit bag.'
 Notes for letter to Paul Green-Armytage, 1997, pencil on paper, 20.8 × 29.7 cm, estate of Howard H Taylor.

15 Howard Taylor, notes on envelope, 1997, black ink on paper, 10 × 23 cm, estate of Howard H Taylor.

16 Howard Taylor, letter to Paul Green-Armytage, quoted in 'Learning from Howard Taylor', lecture at Howard Taylor
 Symposium, Art Gallery of Western Australia, 5 September 1998.

17 Howard Taylor described his success with *Weathered jarrah* in a letter to the author, 1 May 1997:
 'You may recall when you were last here that I thought of making use somehow of all those nice bits of wood
 collected over the years. There has been some luck with a couple of jobs, and that huge weathered piece has been
 thinned down to lose weight and now sits on the wall up from the floor and with a small addition below has a nice
 feeling of floating – with an aerial sense of landscape.'

18 Howard Taylor, notes on *The black stump* 1975, c1987, pencil on paper, 12 × 15.8 cm irregular, estate of Howard H Taylor.

19 CG Hamilton, 'Howard Taylor. A very good painter', in 'Notebook 1958–1962', Art Gallery of Western Australia,
 artist's biographical file.

20 Howard Taylor, draft notes for 'Light Source: Reverse' 1997, pencil on paper, 29.8 × 21 cm, estate of Howard H Taylor.

21 Howard Taylor, notes for letter to Paul Green-Armytage, 1997, pencil on paper, 20.8 × 29.7 cm, estate of Howard H Taylor.

22 Howard Taylor, pencil note in the artist's hand, c1990, estate of Howard H Taylor.

23 Gerhard Richter, 'Interview with Rolf Gunther Dienst', 1970, in *The daily practice of painting*, ed. Hans-Ulrich Obrist,
 trans. David Britt, Thames & Hudson, London, 1995, p. 63.

24 Howard Taylor, notes for letter to Paul Green-Armytage, 1997, pencil on paper, 29.7 × 21.4 cm, estate of Howard H Taylor.

25 Howard Taylor, annotation on a schematic drawing of *Light figure* 1992 in Howard Taylor, 'painting' diary, dated by the artist 1992–93, estate of Howard H Taylor.

26 Paul Hills, *Venetian colour marble, mosaic, painting and glass 1250–1550*, Yale University Press, New Haven, 1999, p. 146.

27 ibid.

28 Howard Taylor, notes in sketchbook 82D, 1982, estate of Howard H Taylor.

29 Howard Taylor, notes for artist's statement on *Sphere* and *Sun wall* 1998, pencil and black ink on paper, 29.8 × 20.8 cm, estate of Howard H Taylor.

30 Howard Taylor, 'painting' diary, dated by artist 1956, estate of Howard H Taylor.

31 Howard Taylor, letter to author, 1 May 1997, Art Gallery of Western Australia.

32 Howard Taylor, notes in sketchbook 68A, 1968, estate of Howard H Taylor.

33 Howard Taylor, 'We depend so deeply on our experience of nature and the experience of others with it. It is the basis of our visual perception and the principles of design', notes for letter to Paul Green-Armytage, 1998, black ink on paper, 29.7 × 20.6 cm, estate of Howard H Taylor.

VISUAL EXPERIENCE AND PICTORIAL STRUCTURE *pages 33 to 51*

1 Conversation with the artist, 17 July 1985 (Perth).

2 Conversation with the artist, 25 October 1984 (Northcliffe). All subsequent quotations from Howard Taylor are drawn from this interview except as indicated.

3 *The Sphinx*, vol. 10, no. 67, Perth Modern School, November 1936, p. 30.

4 Jill Crommelin, 'POW camp therapy leads to exhibition', *West Australian*, December 1970.

5 Howard Taylor and Western Australian artist Guy Grey-Smith (1916–1981) first met in a POW camp. Taylor placed special emphasis on the seminal importance of this period in POW camps when providing a chronology of his development for the Art Gallery of Western Australia artist biographical files in 1954.

6 'Art exhibition', *West Australian*, 13 September 1949, p. 12.

7 CG Hamilton, 'Display of two arts', *West Australian*, 11 April 1951, p. 7.

8 'Awards in art', *West Australian*, 14 July 1951, p. 4.

9 James Cook was appointed curator of the Art Gallery of Western Australia in March 1950. He continued in the position until early 1952.

10 Paul Nash, 'Picture history: notes on his work 1933 to 1945' prepared for his dealers, Arthur Tooth & Sons, 1943–1945, published in *Paul Nash paintings and watercolours*, Tate Gallery, London, 1975, p. 98.

11 Beginning with *March personage* 1935, Paul Nash uses found objects to represent the collected natural objects as protagonists in the visual dramas of his paintings.

12 Andrew Causey, 'The art of Paul Nash' in *Paul Nash paintings and watercolours*, Tate Gallery, London, 1975, p. 22.

13 'Nature played an important role in English surrealism. Unlike their French counterparts, who combed the flea markets and junk shops of Paris, the English turned to the seashore and countryside for their 'chance discoveries'. They recognised that nature could arrange the incongruous, and mould and transform the ordinary to create an awesome fantasy.' Charles Harrison, 'Sculpture and the new "New Movement"' in *British sculpture in the twentieth century* (exhibition catalogue), ed. Nairne and Serota, Whitechapel Art Gallery, London, 1981.

14 Howard Taylor, letter to Gary Dufour, 1 February 1985.

15 CG Hamilton, 'Notebook 1958–1962', Art Gallery of Western Australia, artist's biographical file.

16 Bridget Riley is a British artist widely respected for her contribution to 'Op Art' from the 1960s to the present. Bridget Riley and Bryan Robertson, due to delays in their travel as a result of an airline strike, were taken to visit Howard Taylor in Northcliffe by Tedye and Bryant McDiven. Taylor credits this introduction and Riley's enthusiastic support as being instrumental in his securing a solo exhibition at Coventry Gallery in Sydney in 1978.

IN A SILENT WAY *pages 53 to 57*

1 Alberto Manguel, *Reading pictures*, Bloomsbury, London, 2000, p. 292.

2 Howard Taylor in an interview with Duncan Graham, 'Big timber man', *National Times*, 19 May 1979, p. 49.
 Quoted in Ted Snell, *Howard Taylor: forest figure*, Fremantle Arts Centre Press, Fremantle, 1995, p. 94.

3 Mary Eagle wrote of Taylor: 'So beware Howard Taylor, who emulates the sun. Beware too, the option of naming his art.
 There is not a name to fit.' Mary Eagle and Daniel Thomas (eds), *1990 Adelaide Biennial of Australian Art*
 (exhibition catalogue), Art Gallery of South Australia, Adelaide, 1990, p. 78.

4 CG Hamilton, 'Several aspects in art show', *West Australian*, 12 July 1960, p. 8.

5 Lynne Seear, 'Howard Taylor – driven to abstraction', in Lynne Seear (ed.), *APT 2002, Asia-Pacific Triennial of
 Contemporary Art* (exhibition catalogue), Queensland Art Gallery, Brisbane, 2002, p. 106.

6 Rainer Maria Rilke, letter dated 10 October 1907, in Clara Rilke (ed.), *Letters on Cèzanne*, Vintage, London, 1985, p. 43.

7 Ian Burn, 'Fred Williams: That is how a landscape should be, even if it isn't', in *Dialogue: Writings in Art History*,
 Allen & Unwin, 1991, pp. 86–93.

8 Howard Taylor, interview with Gary Dufour, 1984. Quoted in Snell, *Howard Taylor*, p. 36.

9 In its quietness and refinement, Taylor's work encourages a contemplative, even spiritual response, something the
 artist denied, claiming that it is the result of practical procedures … The more intangible aspects are not encouraged in
 making what I make – suspect – known, kept quiet.' Letter to Ted Snell, 1989, quoted in Snell, *Howard Taylor*, p. 130.

10 Howard Taylor, 'Light Source Reverse', *Art & Australia*, vol. 39, no. 3, March–May 2002, p. 389.

11 Howard Taylor, interview with Ted Snell, 1993. Quoted in Snell, *Howard Taylor*, p. 96.

12 'Public commissions were a … useful way for the artist to be employed and a useful way in which the public can
 see art, because normally they don't see it, or even think about it.' Howard Taylor, interview with Gary Dufour, 1984,
 quoted in Snell, *Howard Taylor*, p. 73.

INTERVIEW *pages 59 to 66*

Edited from *Howard Taylor* (Archival Art series). Original interview conducted by James Murdoch at Northcliffe in 1986.
Edited by Gary Dufour in 2003 and reproduced with the permission of the Australia Council. © Australia Council.

LIGHT SOURCE: REVERSE *pages 68 and 69*

An edited version of this text was published posthumously in *Art & Australia,* vol. 39, no. 3, March–May 2002, p. 389.
Six drafts, all in the artist's hand, in pencil and/or ink were produced for 'Light Source: Reverse' 1997.
Taylor also produced one typed manuscript with the same title in 1997.

1 Nicolas Poussin, quoted in Oskar Batschmann, *Dialectics of painting*, Reaktion Books, London, 1990.

PHOTOGRAPHIC CREDITS

Art Gallery of South Australia 112, 119, 136; John Austin 154, 158, 160; Australian Broadcasting Corporation Content Sales 14;
Ben Blackwell 25; Gary Dufour15; Galerie Düsseldorf 27, 30, 56, 132; National Gallery of Australia 40, 121;
National Gallery of Victoria 39, 82, 114; Kerry Stokes Collection 16; Estate of Howard H Taylor 21, 34, 44, 47; Greg Weight 125;
Richard Woldendorp 2, 51, 140

List of Works

All works are listed by title and date. The majority of works are inscribed with title and date on the verso in the artist's hand. All other titles were verified using the artist's day diary and exhibition checklists. Howard Taylor rarely exhibited a work of art without giving it a title. If a work did not have a title, it is listed as Untitled followed by a descriptive title enclosed in square brackets. Descriptive titles in italics were selected from titles used by Howard Taylor and assigned by the curator.

Measurements are given in centimetres in order: height, width and depth.

Howard Taylor painted in a variety of mediums including primarily egg tempera, oil and synthetic polymer paint on composition board, canvas and wooden panels of his own design. These panels were constructed with a western red cedar timber grid and faced on both sides with marine plywood. This support is indicated as panel if the support has a flat two-dimensional surface, shaped panel if the support is a three-dimensional wall relief, and incised panel if any area on the surface of the panel has been incised.

Howard Taylor utilised a technique, established when he began painting in egg tempera in 1950, of pigmented underpainting in gesso and synthetic polymer paint throughout his career. Underpainting medium is not indicated in descriptions.
As part of his painting process Taylor routinely rubbed back the surface of a painting between coats of paint with ground de-salinated cuttlefish bone or pumice. This practice allowed for the application of multiple layers of colour while limiting the increase in impasto.

Many of the paintings from 1950 to 1976 are in the original artist's frame and indicated by the symbol ◊ following the medium description. In general, paintings produced after 1978 were to be exhibited without a frame and are presented in accordance with the artist's instructions.

Watercolours and drawings are on white paper (unless otherwise indicated) and measurements given for the sheet.

Where possible, the type of timber used in sculptures and maquettes is included in the medium description together with an indication of any specific treatments applied to the timber.

Study for *Portrait of a blackboy* 1950
pencil on paper
36.6 × 25.3
Estate of Howard H Taylor,
courtesy of Galerie Düsseldorf, Perth

Portrait of a blackboy 1950
egg tempera on composition board ◊
56.8 × 37.8
Private collection, Western Australia

The column 1950
watercolour, pastel, pen and ink on card ◊
38.3 × 28.2
Private collection, Kalamunda,
Western Australia

The remains 1950
watercolour, pastel, pen and ink on paper
28 × 38.4
Private collection, Western Australia

Stumps and ash 1951
egg tempera on composition board ◊
40.7 × 50.8
Private collection, Kalamunda,
Western Australia

Creature 1955
oil and tempera on composition board ◊
41 × 30.5
Private collection, Cottesloe,
Western Australia

Untitled [*Structure–chiaroscuro*] 1955
oil on composition board ◊
58.5 × 85
Private collection, Perth

Study for *Interlocking trees* 1956
pencil on paper
19.8 × 16.3
Estate of Howard H Taylor,
courtesy of Galerie Düsseldorf, Perth

Study for *Tree cylinder* 1956
pencil on paper
two sheets: a) 19.8 × 16.3 b) 19.8 × 16.3
Estate of Howard H Taylor,
courtesy of Galerie Düsseldorf, Perth

Tree cylinder 1956
oil on composition board ◊
61 × 41.4
Private collection, Western Australia

Study for *Wood structure* 1956
pencil on paper
two sheets: a) 16.9 × 20.2
b) 16.3 × 20.2
Estate of Howard H Taylor,
courtesy of Galerie Düsseldorf, Perth

Wood structure 1956
oil on composition board ◊
60.8 × 101.5
Art Gallery of Western Australia

Bush structure – flight 1956
oil on composition board ◊
70.8 × 121.8
Art Gallery of Western Australia

Flight 1956
gesso, gouache, pencil, oil and
aluminium foil on composition board ◊
45.8 × 61
Private collection, Claremont,
Western Australia

Untitled [*Object in space*] 1956
synthetic polymer paint on iron
10.4 × 18.8 × 14.9
Art Gallery of Western Australia
Gift of Howard and Sheila Taylor, 2000

Untitled [*Spheres in space*] c1956–1958
pencil on paper
two sheets: a) 19 × 14.4
b) 19 × 14
Estate of Howard H Taylor,
courtesy of Galerie Düsseldorf, Perth

Stick insect 1957
scorched and oiled jarrah
30.5 × 7.5 × 8.5
Art Gallery of Western Australia
Gift of Howard and Sheila Taylor, 2000

Stick insect 1958
scorched jarrah and steel bolts
255 × 65.5 × 39.5
Art Gallery of Western Australia

Untitled [*Object in space*] 1958
oil on composition board
84.1 × 105.3
National Gallery of Victoria, Melbourne
Presented by the National Gallery
Society of Victoria, 1991

In the corner 1958
oil on composition board ◊
84 × 52.5
Art Gallery of Western Australia
Purchased with funds from the
Sir Claude Hotchin Art Foundation, 1999

Study for *Double self-portrait* 1959
pencil on paper
two sheets: a) 28.2 × 19.6 b) 28.2 × 19.6
Estate of Howard H Taylor,
courtesy of Galerie Düsseldorf, Perth

Double self-portrait 1959
oil on composition board
73 × 85.2
Art Gallery of Western Australia

Untitled [*Tree trunks*] 1960
watercolour and ink on paper
11 × 19.1
Estate of Howard H Taylor,
courtesy of Galerie Düsseldorf, Perth

Untitled [*Flying object*] c1960–1963
WA sheoak
108.8 × 9.9 × 17
Private collection, Claremont,
Western Australia

Bush form 1963
synthetic polymer paint on jarrah
and Douglas fir
126.5 × 84.6 × 7.5
Art Gallery of Western Australia

Karri forest 1963
oil on composition board ◊
49.7 × 118.5
Kerry Stokes Collection, Perth

Untitled [*Trees to sky*] 1963
oil on composition board ◊
128.5 × 56.5
Private collection, Mundaring,
Western Australia

Column 1969
jarrah and oil on composition board
11.7 × 4 × 4
Art Gallery of Western Australia
Gift of Howard and Sheila Taylor, 2000

Classical figure II (blackboy derivation)
1969
jelutong and synthetic polymer paint
on jarrah
20.2 × 5.8 × 4.8
Art Gallery of Western Australia
Gift of Howard and Sheila Taylor, 2000

Column 1970
jarrah
141 × 45.5 × 45.5
Art Gallery of Western Australia

Turn about 1970
jarrah and wandoo
107 × 105 × 93
Art Gallery of Western Australia

Figure impinged 1970
WA sheoak and composition board
29.5 × 3 × 16
Art Gallery of Western Australia
Gift of Howard and Sheila Taylor, 2000

Maquette for *The black stump* 1974
synthetic polymer paint, pencil and ink
on wood, composition board and jarrah
40.5 × 54.3 × 18.5
Art Gallery of Western Australia
Gift of Howard and Sheila Taylor, 2000

Torso of a tree fork 1975
scorched and burnished jarrah
15.2 × 7.7 × 4
Art Gallery of Western Australia
Gift of Howard and Sheila Taylor, 2000

Study for *Wood on the ground* c1975
jarrah and composition board
7.9 × 12.2 × 2.2
Art Gallery of Western Australia
Gift of Howard and Sheila Taylor, 2000

Rainbow trace 1976
oil on composition board ◊
22.3 × 28.8
Private collection, Fremantle,
Western Australia

Trees and sky 1976
oil on composition board ◊
22 × 28.7
The University of Western Australia
Art Collection, Gift of the Visual Arts
Board of the Australia Council, 1977

Rainbow and supernumerary 1976
oil on composition board ◊
21.7 × 30.5
Collection Sue and Ian Bernadt

Through the window 1976
oil on composition board ◊
30.5 × 21.7
Private collection, Cottesloe,
Western Australia

Distant rainbow 1976
oil on composition board
21.7 × 30.5
CTS collection, Claremont,
Western Australia

Rainbow veil 1976
oil on composition board ◊
21.7 × 30.5
Private collection, Western Australia

Sapling 1976
oil on composition board ◊
28.7 × 22
The Holmes à Court Collection,
Heytesbury

Northcliffe across the paddock 1976
oil on composition board
22.5 × 36.2
Art Gallery of Western Australia
Gift of Sue and Ian Bernadt, 1991

Forest figure 1977
oil on two shaped panels and
zinc-coated steel cylinder
152.5 × 137 × 15.2
Art Gallery of Western Australia
Purchased with funds from the
Art Acquisition Trust, 1989

Plant figure 1977
oil on jelutong and composition board
25.3 × 13.9 × 1.3
Art Gallery of Western Australia
Gift of Howard and Sheila Taylor, 2000

Figure in space 1978
chalk on shaped WA blackbutt
with steel pin
4.7 × 7 × 3
Art Gallery of Western Australia
Gift of Howard and Sheila Taylor, 2000

Two phases 1978
stem wood and steel pins
overall 9.8 × 8.5 × 1
two elements a) 8.5 × 7 × 1
b) 8.6 × 5.1 × 1
Art Gallery of Western Australia
Gift of Howard and Sheila Taylor, 2000

Landscape 1978
oil on shaped wood
13.3 × 10.5 × 5.5
Art Gallery of Western Australia
Gift of Howard and Sheila Taylor, 2000

Tree form 1980
split jarrah
34.5 × 27 × 10
Estate of Howard H Taylor,
courtesy of Galerie Düsseldorf, Perth

Study for *Heightened with light* 1980
oil and ink on composition board and
synthetic polymer paint on wood
15 × 23 × 3.5
Estate of Howard H Taylor,
courtesy of Galerie Düsseldorf, Perth

Heightened with white 1980
oil on panel and zinc-coated steel cylinder
121.5 × 182.5 × 25.8
Estate of Howard H Taylor,
courtesy of Galerie Düsseldorf, Perth

Study for *Forest land* 1982
oil on composition board
10.2 × 15.4 × 1.7
Collection Douglas and Magda Sheerer,
Galerie Düsseldorf, Perth

Forest land 1982
oil and wax on shaped panel
142.5 × 213 × 11
Art Gallery of Western Australia

Open country I 1982
oil on two panels
119.5 × 182.5
The Holmes à Court Collection,
Heytesbury

Open country II 1982
oil on two panels
119.5 × 182.5
The Holmes à Court Collection,
Heytesbury

Study for *Masked landscape* 1982
oil on composition board
11.6 × 14
Estate of Howard H Taylor,
courtesy of Galerie Düsseldorf, Perth

Charred forest fragment c1983
burnt jarrah
33 × 24 × 18
Estate of Howard H Taylor,
courtesy of Galerie Düsseldorf, Perth

Untitled [*Object in niche*] c1983
synthetic polymer paint on wood
and composition board
14.2 × 10.7 × 2.7
Art Gallery of Western Australia
Gift of Howard and Sheila Taylor, 2000

Masked landscape 1984
oil on panel
91 × 136
Art Gallery of Western Australia

Landscape emblem 1984
oil on panel
102 × 144.8
The Holmes à Court Collection,
Heytesbury

Light 1986
oil on canvas ground on panel
95 × 95
Private collection, Western Australia

Green paddock illuminated 1986
oil on canvas
121.5 × 82.5
Art Gallery of Western Australia

Study for *Segment of a sphere* 1987
synthetic polymer paint on shaped
card and composition board
17 × 17.3 × 3.9
Art Gallery of Western Australia
Gift of Howard and Sheila Taylor, 2000

Segment of a sphere 1988
oil on jarrah
36.5 × 36.5 × 10
Art Gallery of Western Australia

On the ground 1989
pastel on brown paper
28.5 × 31.5
Art Gallery of Western Australia

Study for triptych 1989
pastel on brown paper
31.5 × 28.5
Collection Mandy Loton, Perth

Sun figure 1989
oil on canvas
90 × 120
Art Gallery of South Australia, Adelaide
South Australian Government Grant, 1991

Object on the ground 1989
oil on canvas
90.5 × 120
Art Gallery of Western Australia

Sphere 1989
synthetic polymer paint on panel
85.5 × 111.8
National Gallery of Victoria, Melbourne
Purchased with Trustee Funds, 1991

Hollow 1990
graphite and synthetic polymer paint
on shaped zinc-coated steel
12.9 × 12.3 × 2.3
Art Gallery of Western Australia
Gift of Howard and Sheila Taylor, 2000

Untitled [*Landscape*] c1990
pastel on shaped card with two
paperboard boxes
10.9 × 13.2 × 3.4
Art Gallery of Western Australia
Gift of Howard and Sheila Taylor, 2000

Study for *Discovery* c1990
oil on shaped zinc coated steel
13.2 × 12.2 × 2.2
Art Gallery of Western Australia
Gift of Howard and Sheila Taylor, 2000

Study for *Discovery* c1990
oil on shaped zinc-coated steel
13.2 × 12.7 × 2
Art Gallery of Western Australia
Gift of Howard and Sheila Taylor, 2000

Study for *Light figure* 1992
oil on composition board
13.6 × 30.4
Collection Douglas and Magda Sheerer,
Galerie Düsseldorf, Perth

Light figure 1992
oil on three panels
119.7 × 269.5
Art Gallery of Western Australia
Purchased with funds from the
Sir Claude Hotchin Art Foundation, 1993

Tree line with blue cloud 1993
oil on panel
60.7 × 121.8
The Edith Cowan University
Art Collection, Perth

Tree line with cloud shadow 1993
oil on panel
60.7 × 121.8
Collection Robin and Liz, Andrew
and Fiona Forbes, Perth

Tree line 1993
oil on panel
60.7 × 121.8
Collection Douglas and Magda Sheerer,
Galerie Düsseldorf, Perth

Study for *Four part unit* 1993
meranti and WA sheoak
19.7 × 6.3 × 3
Art Gallery of Western Australia
Gift of Howard and Sheila Taylor, 2000

Study for *Four part unit* 1993
synthetic polymer paint on wood
19.6 × 6.2 × 3.2
Art Gallery of Western Australia
Gift of Howard and Sheila Taylor, 2000

Study for *Contracurve* 1993
synthetic polymer paint and enamel on pine
23.4 × 13.3 × 2
Art Gallery of Western Australia
Gift of Howard and Sheila Taylor, 2000

Untitled [*White figure*] c1993
synthetic polymer paint and enamel on wood
10.2 × 18.2 × 2.1
Art Gallery of Western Australia
Gift of Howard and Sheila Taylor, 2000

On the wall 1994
pastel on brown paper
27.5 × 36.7
Collection Evan and Allie Kakulas

Study for *Internal cylinder* 1994
synthetic polymer paint on jelutong
17.6 × 4.6 × 4.5
Art Gallery of Western Australia
Gift of Howard and Sheila Taylor, 2000

Study for *No horizon* 1994
synthetic polymer paint on wood
15.4 × 14.5 × 4.2
Art Gallery of Western Australia
Gift of Howard and Sheila Taylor, 2000

Untitled [*Contracurve*] 1994
synthetic polymer paint on wood
20.5 × 10.3 × 2.0
Art Gallery of Western Australia
Gift of Howard and Sheila Taylor, 2000

Study for *Heavy object* 1994
WA blackbutt
4.3 × 9 × 3.1
Art Gallery of Western Australia
Gift of Howard and Sheila Taylor, 2000

Study for *Heavy object* 1994
graphite over synthetic polymer paint
on wood
6.5 × 13 × 4.3
Estate of Howard H Taylor,
courtesy of Galerie Düsseldorf, Perth

Study for *Light source reverse* 1994
pastel on paper and composition board
18.3 × 18.3 × 0.6
Art Gallery of Western Australia
Gift of Howard and Sheila Taylor, 2000

Still life with black figure 1994
synthetic polymer paint and oil on canvas
92 × 152.5
Collection Douglas and Magda Sheerer,
Galerie Düsseldorf, Perth

Light source reverse 1994
oil on panel and synthetic polymer paint
on composition board
209 × 209 × 9
Art Gallery of Western Australia
Purchased with funds from the
Sir Claude Hotchin Art Foundation,
1995

Contracurve 1994
synthetic polymer paint and oil
on shaped panel
240 × 133 × 20
Art Gallery of South Australia, Adelaide
South Australian Government Grant,
1995

Heavy object 1994
synthetic polymer paint on shaped panel
92 × 155 × 70
Collection of Brett and Pieta Taylor,
Northcliffe, Western Australia

No horizon 1994
synthetic polymer paint on shaped panel
183 × 170 × 45
National Gallery of Australia, Canberra

Internal cylinder 1994
synthetic polymer paint and oil
on marine plywood
126 × 31 × 31
The Edith Cowan University
Art Collection, Perth

Four part unit 1994
synthetic polymer paint and oil
on marine plywood
134 × 44.7 × 22.5
Estate of Howard H Taylor,
courtesy of Galerie Düsseldorf, Perth

Foliage panels 1994
synthetic polymer paint on two panels
198 × 185 × 2
Collection Douglas and Magda Sheerer,
Galerie Düsseldorf, Perth

Winged figure 1995
synthetic polymer paint on three panels
286.5 × 217.5 × 13
Art Gallery of Western Australia
Purchased with funds from the
Sir Claude Hotchin Art Foundation, 1995

Study for *Strange formations* 1995
synthetic polymer paint on shaped wood
two elements: a) 1.9 × 19.2 × 7.1
b) 4.1 × 35.2 × 14.8
Art Gallery of Western Australia
Gift of Howard and Sheila Taylor, 2000

Study for *Projection* 1995
pastel on western red cedar with
steel pin
13.8 × 13.8 × 1.9
Art Gallery of Western Australia
Gift of Howard and Sheila Taylor, 2000

Columns 1995
pencil, watercolour and synthetic polymer
paint on paper and western red cedar
38.7 × 84.8 × 12.6
Art Gallery of Western Australia
Gift of Howard and Sheila Taylor, 2000

Colonnade study 1995
synthetic polymer paint on panel
85 × 204
Collection Reg and Sally Richardson,
Sydney

Farm landscape 1996
oil on panel
100 × 240
Art Gallery of Western Australia
Purchased with funds from the
Sir Claude Hotchin Art Foundation,
1996

Sphere 1996
oil on canvas
122 × 121.6
Private collection, Safety Bay,
Western Australia

Bush fire day 1996
synthetic polymer paint and oil on panel
82.5 × 144.5
Private collection, Safety Bay,
Western Australia

Moon passing 1996
oil on panel
82.5 × 120.8
Private collection, Claremont,
Western Australia

Study for *Weathered jarrah* 1996
ink, watercolour and synthetic polymer
paint on card, composition board,
jarrah and western red cedar
25 × 31.5 × 7.5
Art Gallery of Western Australia
Gift of Howard and Sheila Taylor, 2000

Study for *Forest post* 1996
Douglas fir and jelutong
19.2 × 5.5 × 4.6
Art Gallery of Western Australia
Gift of Howard and Sheila Taylor, 2000

Study for *Sun wall* 1997
oil on incised composition board ◊
19 × 16.3
Collection Magda Sheerer,
Galerie Düsseldorf, Perth

Sun wall 1997
oil on incised panel
141.5 × 119.8
Collection Sue and Ian Bernadt

Day time moon 1997
synthetic polymer paint and oil on panel
120 × 141
Art Gallery of Western Australia
Gift of the Friends of the Art Gallery
in honour of Judy Hughes, 1997

Weathered jarrah 1997
jarrah and synthetic polymer paint
on shaped panel
280 × 110 × 37
Estate of Howard H Taylor,
courtesy of Galerie Düsseldorf, Perth

Tree fork fragment 1997
oil on canvas
123 × 92
Collection Peter Myers, Sydney

Charred forest fragment 1997
oil on canvas
122 × 92
Art Gallery of Western Australia
Purchased with funds from the
Sir Claude Hotchin Art Foundation,
1998

Study for *Column* 1997
jarrah, paper and chalk
22.3 × 3.5 × 3.5
Art Gallery of Western Australia
Gift of Howard and Sheila Taylor, 2000

Column 1998
jarrah and synthetic polymer paint
277 × 45 × 45
Art Gallery of Western Australia
Purchased with funds from the
Sir Claude Hotchin Art Foundation,
1998

Forest post 1998
oil on pine and shaped panel
192 × 56 × 39
Estate of Howard H Taylor,
courtesy of Galerie Düsseldorf, Perth

Studio wall 1999
oil on panel
91 × 140
Art Gallery of South Australia, Adelaide
South Australian Government Grant,
2001

Projection 1999
oil and synthetic polymer paint on panel
118 × 188 × 8.5
Collection Douglas and Magda Sheerer,
Galerie Düsseldorf, Perth

Divided sphere 2000
oil on two shaped panels
99 × 94.5 × 8.5
Kerry Stokes Collection, Perth

Discovery 2000
oil on incised shaped panel
200 × 193 × 36
Estate of Howard H Taylor,
courtesy of Galerie Düsseldorf, Perth

Untitled [*Figure in space*] 2001
oil on composition board
12.8 × 22.9
Estate of Howard H Taylor,
courtesy of Galerie Düsseldorf, Perth

Untitled [*Construction on the wall*] 2001
synthetic polymer paint on marine
plywood
70 × 100 × 10.5
Estate of Howard H Taylor,
courtesy of Galerie Düsseldorf, Perth

Biography

1918	29 August, born in Hamilton, Victoria. Son of Eleanor Minnie and Charles Edmund Taylor. Lives in South Australia until 1932.
1932	Family moves to Perth, Western Australia. Studies at Perth Modern School.
1937	21 July, enlists in the Royal Australian Air Force. Goes to Point Cook, Victoria, for pilot training.
1938	Awarded Sword of Honour as pilot of the year. Goes to United Kingdom. 25 July transfers to RAF. Certified as Pilot Officer, 11 January 1939.
1940	Interned as a World War II prisoner of war from 19 May 1940 until the end of the war, in POW camps *Dulag Luft* Oberwesel, *Oflag IXA* Spangenberg, *Oflag VIB* Warburg and *Stalag Luft III* Sagan (Germany) and *Stalag XXA* Thorn and *Oflag XXIB* Schubin (Poland).
1945	22 November, returns to Perth.
1946	20 February, demobilised from RAAF. Returns to United Kingdom. Marries Sheila Smith. Enrols as a part-time student at the Birmingham College of Art on an RAAF rehabilitation grant.
1949	January, returns with family to Western Australia and establishes home and studio in Bickley. First solo exhibition at Newspaper House Gallery.
1951	Teaches painting and drawing at Perth Technical College; continues in this position (part-time) until 1965.
1960	Visits the United Kingdom and Europe with Sheila for six months. Sculpture commission: Fremantle Passenger Terminal murals, Fremantle Port Authority.
1965	Teaches painting, drawing and sculpture at the School of Architecture and Planning, Western Australian Institute of Technology; continues in this position (part-time) for four years.
1967	Moves to Northcliffe, Western Australia.
1975	Awarded Western Australian Arts Council Fellowship. Sculpture commission: *The black stump*, AMP Fire and General Insurance Co., Perth.
1977	Appointed Artist-in-Residence, Western Australian Institute of Technology.
1978	Awarded Visual Arts Board Grant, Australia Council. Sculpture commission: *Way through*, Western Australian Institute of Technology.
1980	Sculpture commission: *Forest trees*, City of Bunbury. Visits the United Kingdom.
1986	Receives Australia Council Emeritus Award.
1988	Sculpture commission: *Compass and perspective*, Parliament House, Canberra.
1989	Appointed a Member of the Order of Australia.
1991	Appointed a Fellow, Curtin University of Technology, Perth.
1993	Receives honorary degree of Doctor of Letters, University of Western Australia, Perth.
1999	Honoured by the Western Australian State Government as a 'Living Treasure'.
2000	Receives Lifetime Achievement Award, Citizen of the Year Awards, Western Australian State Government.
2001	Receives honorary degree of Doctor of Technology, Curtin University of Technology, Perth. 19 July, dies in Perth.

One-Person Exhibitions

1949 Oils, Egg Tempera and Watercolours by Howard Hamilton Taylor, Newspaper House Art Gallery, Perth 6–17 September.

1951 Paintings by Howard Taylor, Newspaper House Art Gallery, Perth 19–28 April.
Howard H Taylor: A Private View of his Paintings (in oils, egg tempera and watercolours), The Lesser Hall,
Northam 15 September.

1957 Paintings, Sculptures & Reliefs by Howard Taylor, Adult Education Board of Western Australia, Perth 9–21 December.

1960 Exhibition of Paintings, Howard Taylor, Skinner Galleries, Perth 11–16 July.

1963 Western Australia Pavilion, Sydney Trade Fair, Sydney 26 July – 10 August.
Howard Taylor – Paintings, Drawings, Reliefs, Skinner Galleries, Perth 2–7 December.

1967 Sale by Auction of Paintings and Sculpture by Howard Taylor, 'Aldersyde', Bickley 17 June.

1970 Sculptures by Howard Taylor, Skinner Galleries, Perth 1–15 December.

1971 Sculptures by Howard Taylor, The University of Western Australia, Perth 1 February – 6 March.

1974 Howard Taylor, Skinner Galleries, Perth 19 November – December.

1977 Howard Taylor – Paintings and Sculpture, Nolan Room, Undercroft Art Gallery, The University of Western Australia, Perth
15 March – 6 April.

1978 Figures in Landscape, Western Australian Institute of Technology, Perth 10 February – 10 March.
Howard Taylor, Coventry Gallery, Sydney 5–23 September.

1981 Howard Taylor, Quentin Gallery, Perth 6–23 August.

1982 Howard Taylor Drawing–Painting–Sculpture, Old Court House Art Centre, Busselton 1–20 March.

1985 Howard Taylor Sculptures · Paintings · Drawings ·1942–1984, Art Gallery of Western Australia 13 April – 2 June.

1986 Howard Taylor: Skeletal Remains, Nolan Room, Undercroft Art Gallery, The University of Western Australia, Perth
22–26 September.

1988 Recent Paintings and Drawings by Howard Taylor, Galerie Düsseldorf, Perth 5 June–3 July.

1989 Howard Taylor: Flowers, Galerie Düsseldorf, Perth 4–25 June.

1990 Howard Taylor: Paintings – Pastels, Galerie Düsseldorf, Perth 13 February–13 March.

1992 Howard Taylor: In Private Hands, Erica Underwood Gallery, Curtin University of Technology, Perth 1–30 October.

1993 Howard Taylor Maquettes: Studies and Finished Works 1970s and 1980s, Art Gallery of Western Australia
13 March–26 April.
Howard Taylor: Paintings and Drawings, Galerie Düsseldorf, Perth 1–29 August.

1995 Howard Taylor: Constructions–Paintings–Drawings–Maquettes, Galerie Düsseldorf, Perth 7 March – 23 April.

1996 Howard Taylor, Art Gallery of Western Australia 15 February – 28 May.
Howard Taylor: Paintings – Drawings, Galerie Düsseldorf, Perth 1–22 September.
Howard Taylor, Fifth Australian Contemporary Art Fair, Melbourne 2–6 October.

1998 Howard Taylor, Art Gallery of Western Australia 1 August – 6 September.
 Howard Taylor: Paintings–Sculptures–Drawings, Galerie Düsseldorf, Perth 6–27 September.

1999 Howard Taylor – Paintings & Drawings, Annandale Galleries, Sydney 13 April–8 May.
 Howard Taylor: Significant Works from the 60s: Paintings–Sculpture–Drawings, Galerie Düsseldorf, Perth
 26 September – 17 October.

2000 Howard Taylor: Recent Work: Wall Sculptures–Paintings–Drawings, Galerie Düsseldorf, Perth 20 August – 17 September.

2001 Howard Taylor: P.O.W. Drawings, John Curtin Gallery, Curtin University of Technology, Perth 28 July – 3 September.
 Forest Radiance: Howard Taylor, John Curtin Gallery, Curtin University of Technology, Perth 20 September – 11 November.
 25th Anniversary / Galerie Düsseldorf: A Dedicated Tribute to Howard Taylor 1918 – 2001, Galerie Düsseldorf, Perth
 11 November – 16 December.

2002 Howard Taylor: Paintings–Maquettes–Drawings, Galerie Düsseldorf, Perth 1 September – 6 October.

2003 Howard Taylor Phenomena, Museum of Contemporary Art, Sydney 17 September – 30 October;
 Art Gallery of Western Australia 5 February – 2 May 2004.

2004 Howard Taylor, Galerie Düsseldorf, Perth 15 February – 28 March.

Howard Taylor, Northcliffe 1988

Group Exhibitions

1949 **Annual Art Competition,** Art Gallery of Western Australia June.

1950 **Annual Art Competition,** Art Gallery of Western Australia 10 July – 2 August.

1951 **For the Heart's Sake: Exhibition of Oil and Watercolours to help the 'National Heart Foundation Appeal,** Claude Hotchin Art Gallery, Boans Ltd, Perth 21 June – 1 July.
Annual Art Competition and Commonwealth Jubilee Open Art Competition, Art Gallery of Western Australia 17–27 July.
Western Australian Jubilee Exhibition of Paintings, Art Gallery of Western Australia 17–27 July.

1953 **Annual Art Competition,** Art Gallery of Western Australia July–August.

1954 **Festival Exhibition of Contemporary Australian Art,** Art Gallery of Western Australia 7–31 January.

1955 **The Perth Prize for Contemporary Art,** Art Gallery of Western Australia 2 August – September.

1956 **First Festival of Perth Open-Air Art Exhibition,** Supreme Court Gardens, Perth 3–18 March.

1957 **First Tasmanian Art Gallery Exhibition,** Tasmanian Museum and Art Gallery, Hobart 27 March – 28 April.
The Perth Prize for Contemporary Art, Art Gallery of Western Australia 7 August – 5 September.

1958 **Second Tasmanian Art Gallery Exhibition,** Tasmanian Museum and Art Gallery, Hobart 26 March – 27 April.

1962 **Painters' Progress,** Art Gallery of Western Australia 3 November – 1 December.

1963 **The Perth Prize 1963,** Art Gallery of Western Australia 24 January – 16 February.
Seventh Tasmanian Art Gallery Exhibition, Tasmanian Museum and Art Gallery, Hobart 28 March – 31 April.
Paintings from the West: 14 Western Australian Painters, Museum of Modern Art and Design of Australia, Melbourne 9–24 April.

1964 **Recent Acquisitions 1963–1964,** Art Gallery of Western Australia 11 July – 9 August.

1965 **Save the Children Fund Art Exhibition,** home of Mrs L Brodie-Hall, Gooseberry Hill, 13–14 November.

1968 **Western Australian Artists,** Old Fire Station Gallery, Perth 18 October – November.

1972 **Annual Invitation Art Exhibition for Original Prints and Drawings,** Architecture Building, Western Australian Institute of Technology, Perth 27 May – 11 June.
Sixteenth Tasmanian Art Gallery Exhibition, Tasmanian Museum and Art Gallery, Hobart 27 June – 30 July.

1973 **Annual Invitation Art Exhibition,** Western Australian Institute of Technology, Perth 1–19 August.

1974 **Western Australian Artists,** Art Gallery of Western Australia 18 February – 17 March.

1975 **Western Australian Artists 1960–1975,** Art Gallery of Western Australia 26 May – 2 June.

1979 **Sculpture in the City II,** Western Australian Sculptors Association, Perth 12 February – 3 March.
Selections from the Graylands Teachers College Art Collection, Undercroft Art Gallery, The University of Western Australia, Perth 5–20 June.

1980 **Perceptions Gallery,** Adelaide March–April.

1981 **Robert Holmes à Court Collection,** Greenhill Gallery, Perth August.
The Salec Minc Collection, Undercroft Art Gallery, The University of Western Australia, Perth 15 September – 9 October.

| **1982** | **Critics' Choice,** Art Gallery of Western Australia 18 February – 22 March. |
| | **The Foulkes Taylor Years,** invitational exhibition organised by the Western Australian Institute of Technology, Galerie Düsseldorf, Perth 12–28 November. |

1983 **Western Australian Paperworks,** Art Gallery of Western Australia 20 August – 25 September; Queens Park Theatre, Geraldton 8–20 October; Claude Hotchin Art Gallery, Albany 26 October – 10 November; Golden Mile Art Gallery, Kalgoorlie 16 November – 1 December; Bunbury City Art Gallery, Bunbury, 3–19 December.

1984 **Australian Sculpture from the Collection,** Art Gallery of Western Australia 9 February – 10 April.
 The W.A.I.T. Collection 1968–1983, Art Gallery of Western Australia 30 April – 6 June.

1987 **Western Australian Art and Artists 1900–1950,** Art Gallery of Western Australia 15 January – 29 March; Bunbury Regional Art Galleries 8 April – 10 May; Geraldton Regional Art Gallery 1 May – 16 June.
 Among the Souvenirs: Western Australian Art in the Eighties, Art Gallery of Western Australia 14 February – 29 March.
 13 Artists at Galerie Düsseldorf, Galerie Düsseldorf, Perth 3 August – 4 October.
 Third Australian Sculpture Triennial, National Gallery of Victoria, Melbourne 16 September – 22 October.

1988 **Western Australian Artists,** Parliament House, Perth 11 May – 15 June.
 The Great Australian Art Exhibition 1788–1988, Queensland Art Gallery, Brisbane 17 May – 17 July; Art Gallery of Western Australia, Perth 13 August – 25 September; Art Gallery of New South Wales, Sydney 21 October – 27 November; Tasmanian Museum and Art Gallery, Hobart 21 December – 5 February 1989; National Gallery of Victoria, Melbourne 1 March – 30 April 1989; Art Gallery of South Australia, Adelaide 23 May – 16 July 1989.

1989 **Heidelberg and Heritage: Two Visions of Australia One Hundred Years Apart,** Linden Gallery, Melbourne.
 Provincialism and Modernism in Perth, Undercroft Art Gallery, University of Western Australia, Perth 6–27 September.

1990 **Adelaide Biennial of Australian Art,** Art Gallery of South Australia, Adelaide 2 March – 22 April.
 What Images Return: Australian Art Since 1940, Art Gallery of Western Australia 1 June – 15 July.

1991 **The Constable Collection,** Lawrence Wilson Art Gallery, The University of Western Australia, Perth 28 May – 25 July.
 Backward Glance, Perth Institute of Contemporary Art, Perth 6–29 September.
 The Skinner Collection, Lawrence Wilson Art Gallery, The University of Western Australia, Perth 8 September – 1 December.
 90 Years: A Retrospective Exhibition of Art from Perth Technical College, Alexander Library, Perth 20 October – 13 December.

1993 **Shaping Western Australia,** Art Gallery of Western Australia 4–28 February.
 The Joan and Peter Clemenger Triennial Exhibition of Contemporary Australian Art, National Gallery of Victoria, Melbourne 23 February – 16 May.

1994 **Tangerine Dreams: A Matter of Western Australian Style 1970–1980,** Lawrence Wilson Art Gallery, The University of Western Australia, Perth 18–28 January.
 At the Front, Art Gallery of Western Australia 16 April – 3 July.
 Recent Acquisitions, Edith Cowan University, Perth 17–27 May.
 Aurora, Craftwest Gallery, Perth 16 June – 24 July.
 The Stein Collection, Lawrence Wilson Art Gallery, The University of Western Australia, Perth 29 October – 3 December.